EUROPEAN
PUBLISHERS
AWARD
FOR PHOTO
GRAPHY
1995

EUROPEAN PUBLISHERS AWARD FOR PHOTOGRAPHY 1995

Jury

Paul Wombell – Director, The Photographers' Gallery, London
Günter Braus – Edition Braus
Sybrand Hekking – Stichting Fragment Foto
Andrés Gamboa – Lunwerg Editores
Dewi Lewis – Dewi Lewis Publishing
Yves-Marie Marchand – Marval
Mario Peliti – Peliti Associati

In collaboration with

and with support from
The Arts Council of England
North West Arts
The Foundation for Sport and The Arts

Stories *of* Women

Copyright © 1995

For this edition
Edition Braus
Stichting Fragment Foto
Lunwerg Editores
Dewi Lewis Publishing
Marval
Peliti Associati

For the photographs
Shanta Rao

For the text
Charles-Henri Favrod
Sélim Nassib

ISBN: 1-899235-30-2

Design
Alan Ward, Axis, Manchester

Translations
Alison Hirst

Layout
Shanta Rao

Photographic prints
Richard Foulser

Duotone separations
Leeds Photo Litho, Leeds

Print
ProStampa Sud Grafica Editoriale, S.Palomba, Rome

Project Leader 1995
Dewi Lewis

EUROPEAN PUBLISHERS AWARD FOR PHOTOGRAPHY 1995

Stories *of* Women
Shanta Rao

text by Charles-Henri Favrod
Sélim Nassib

DEWI LEWIS
PUBLISHING

In Ethiopia

Alemshaye, Almaz, Aster, Enatu,
Meaza, Tsehai and her sisters

In Mauritania

Absatall, Assi, Awahi, Binta, Dalla, Fatou,
Hawa, Nabou, Oumou, Penda, Rajhitou,
Walde and Worokhaya

I would particularly like to thank

Irédé Bada, Emmanuelle Bajac, Frédéric Costa, Judith Depaule,
Nathalie Emprin, Charles-Henri Favrod, Régis Guénolé, the Kidane family, Nabil Korichi,
Olivier Lebé, Karine Modeste, Sélim Nassib, Tasso Papatakis, Guirma Tesfaye, Nicolas Tourlière

and also
Michel Boccara, Serge François, Christophe Léger,
Yves-Marie Marchand, Tadela Tassema, Caroline Terrier and FIACRE (Ministry of Culture, France)

The tracks of Shanta Rao

And Miriam and Aaron spake against Moses
because of the Ethiopian woman whom he had married.
Now the man Moses was very meek, above all the men
which were upon the face of the earth.

The Book of Numbers

Shanta Rao brings together women from Ethiopia and Mauritania. Rather than drawing up an ethnological or geographical report, ranging from one horn of Africa to the other, she records their strength and their languor. But account must certainly be taken of these two extremes in order to better express the feminine constancy which Makedda, the Queen of Sheba, and the even more mysterious Anthinéa foreshadowed.

The Sovereign of the Spices had heard about Solomon through Tamrin, a merchant supplying red gold to the king. Upon her arrival in Jerusalem, she stopped worshipping the sun and the moon, was seduced, and returned from the journey with a son, Ménélik. When he had reached the age of manhood, she sent him to his father to be anointed and crowned emperor of Ethiopia. Solomon proposed that Ménélik should reign in Israel, but could not succeed in getting him to stay. So he gave him an escort of the eldest sons of each of his counsellors. Worried about leaving their native land, these young men stole the Ark and the Tables of the Law. Ménélik carried off these useful trophies.

The legend took shape, particularly when with the expansion of Islam, the Abyssinians were cut off from Christendom. It appears in the *Kebra N-agast*, the Glory of Kings, a ritualistic anthology which Robert Napier got hold of in 1868 and brought back to England with the golden crown of Theodor, and the state tiara and chalice. It became evident to John IV, successor to Theodor, that his subjects no longer recognised his authority and he wrote to Lord Granville to tell him of his dilemma and to ask for his help. Moved by this appeal the administrators of the British Museum returned the essential book to the sovereign.

There is no more enduring way of preserving tracks through time than photography. Shanta Rao excels in capturing life and light, to bring about revealing perspectives and to prompt decoding.

The mineral vastness of Africa is criss-crossed everywhere by scars. It testifies to man's determination to conquer it. From an aeroplane, you discover a network of narrow paths, the *Medjbed*, which generations of caravans have hollowed out. The spongy step of the camel has worn away the slab of

the hamadas, the gravel of the area. An almost capillary network links Mauritania to Ethiopia, finely tracing the trading or the wandering of tribes. In the erg, there are no trails; occasional ashes, droppings, a reed, are the only landmarks. When the topography doesn't allow the surroundings to be watched over the stopping place always backs on to a dune or a rock; and after a detour to put pursuers off the scent. An atavistic caution which more peaceful times have not overcome. The greatest knowledge of a man of the desert is in this word, *djerat* in Arabic, tracks! A Moorish song says: "At the end of the rope, you find the tent peg, just as you find the man at the end of the track". A skillful Saharan interprets marks with the help of minute details: he is able, for example, to specify the composition of a herd or flock, the sex, the type and the age of the animals; to estimate the load, the speed, the time since they passed by; even to assert that a she-camel was blind in one eye because she grazes differently to the others. Whilst on his march to Chad, major Lamy noted in his log-book; "The sand carries printed in it all of Africa's history and takes the place of the best informed newspapers for those who know how to read it."

Photography, a gigantic space of discovery, does this even more; and in a remarkable way when it appears in the form of a deliberate chronicle as that of Shanta Rao. You pass from one story to another, each time with a woman's name as a sign, and you can give yourself up to the charm exercised by the chosen woman who is your guide through the narrative. But if your attention is drawn, then all the signs which give the true direction and orientation are revealed.

The Mauritainian desert, and the Ethiopian mountain shape those who live there. Physiology and psychology are dependent on them. Doctors attribute the sharpness of sight and of hearing to the absence of contrasts, to the need to cross a landscape without apparent landmarks, nearly always dangerous. And from this the photographic impressionability of the brain. The best guides, in the erg, find their way from the dunes; they know the direction of the prevailing winds and remember imperceptible marks. At night, they trust the stars, the pole-star, "the one that doesn't change". They all draw a precise map in the dust with their finger. A prisoner of Bissuel in Algeria, in 1885, Targui Tachcha ag Seragda described the Adrar-Ahnet and, in his cell, made a model of the region, which twenty years later a photographic survey of the land proved to be correct.

Consider then the tracks of Makedda and of Anthinéa which Shanta Rao has picked up so well. Surrender yourself to the grace that she restores, to the symbolic strength of the narrative, to the luminous miracle of photography through which she triumphs. And pick up this book again and again, so that it will work on you like the story of Shéhérazade. "And there was one night and there was one morning…"

Charles Henri-Favrod

A dark country

She says that in the West things overlap each other, until nothing moves anymore! She says she feels paralysed, she wants to go away.

The West can't be left quite so easily. It keeps us captive, prisoners of the dream it needs. But she believes in travel, she says travel is for that, to disarrange things, and the road is the best moment.

She goes quickly by, she stops in cafés, she looks at the outside, bathed too harshly in light. She loses track for days, listening to noises. She meets men, their story is wretched but at least it is theirs. They lock themselves in toilets to cross the borders. She goes through, waits for something to be forgotten inside her head. Time doesn't matter as it did before, if she wanted to lose herself she wouldn't act any differently.

The arrival surprises her, she looks around. Other women are there, women who have their skin lightened, the curls in their hair bleached to look like 60s American girls. They are also captives, of a West of the past, as she is of a happy Africa. No means of escape. In these mirrors their reflections of past times face each other.

She stays with them. The wooden shutters are closed, printing on her body bands of darkness. When she is tired of lying down she gets up and looks outside. Children play around her, perhaps hers, you never knows whose children are whose in Africa. Outside everything is burnt. Why is it burnt like that?

Everything becomes slower, no-one moves. These women, approached without thinking, have been removed from everything, alone and together at the same time, detached. She says that it is as if they were me and not me. She stands in the space between, the blurred zone, like a thief. She is there to capture life. Perhaps a thread still binds her to the West, perhaps that's why she steals. She stays still for a long time, until she feels them swaying.

She opens her eyes again, there are only shadows. She is now one of them. Her joints become loose, the small of her back can support the weight. She has their supple and powerful shoulders, their length of neck. They have entranced her. She no longer feels alone even with the man. She is released from herself. Their skins are porous, the heat dilates them, she is permeable. Enough to no longer be anyone's messenger, enough to disappear.

She is in a dark country, the light has been extinguished. No one sees them, no one can make them out. Some women work in the semi-darkness, putting henna on their feet, their skin perspires. An old woman is going to die, ready to leave, lying under the gaze of dark shapes which dance, very slowly, almost in a trance.

She would like to be there, in this perfect division of darkness and light, that is what she would like. Her journey is an unending transition.

She has returned. She says that she has really left, that she has really found. She shows what she brings back, what stretches behind her... a world motionless in the night. In the West everything is lit, everything is said, nothing resists this light. Yet this world may dream of the West, she insists, and also dream of something else; it dreams of everything. In the kingdom of want only the dream is plentiful. And that is what she brings back, unbroken, like a precious secret.

Sélim Nassib

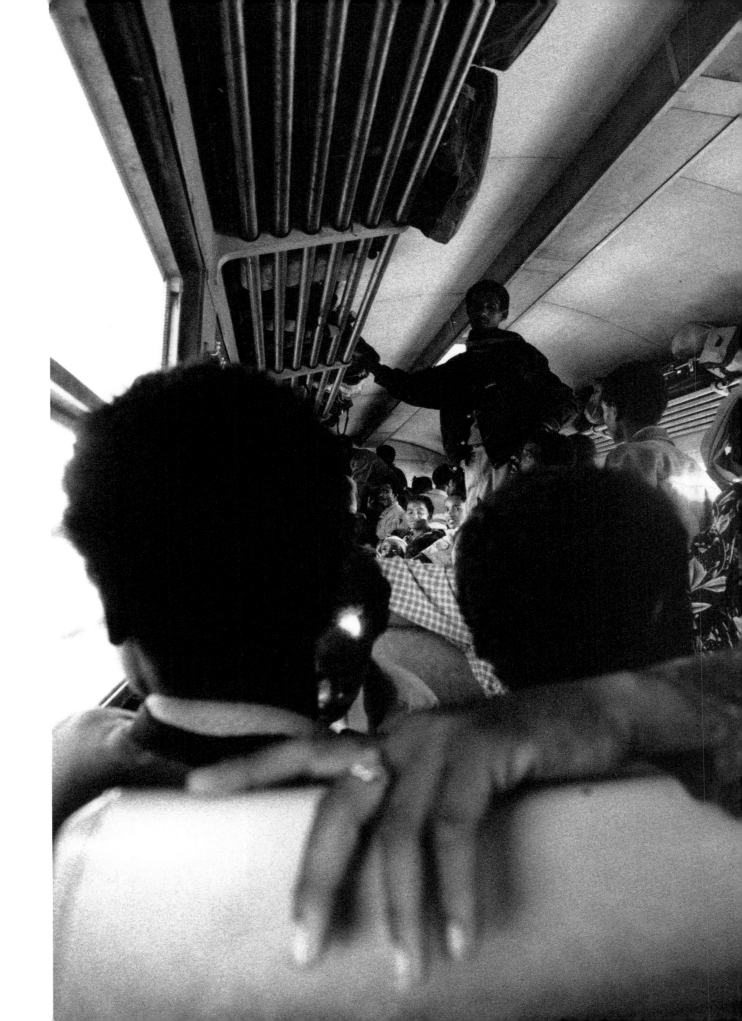

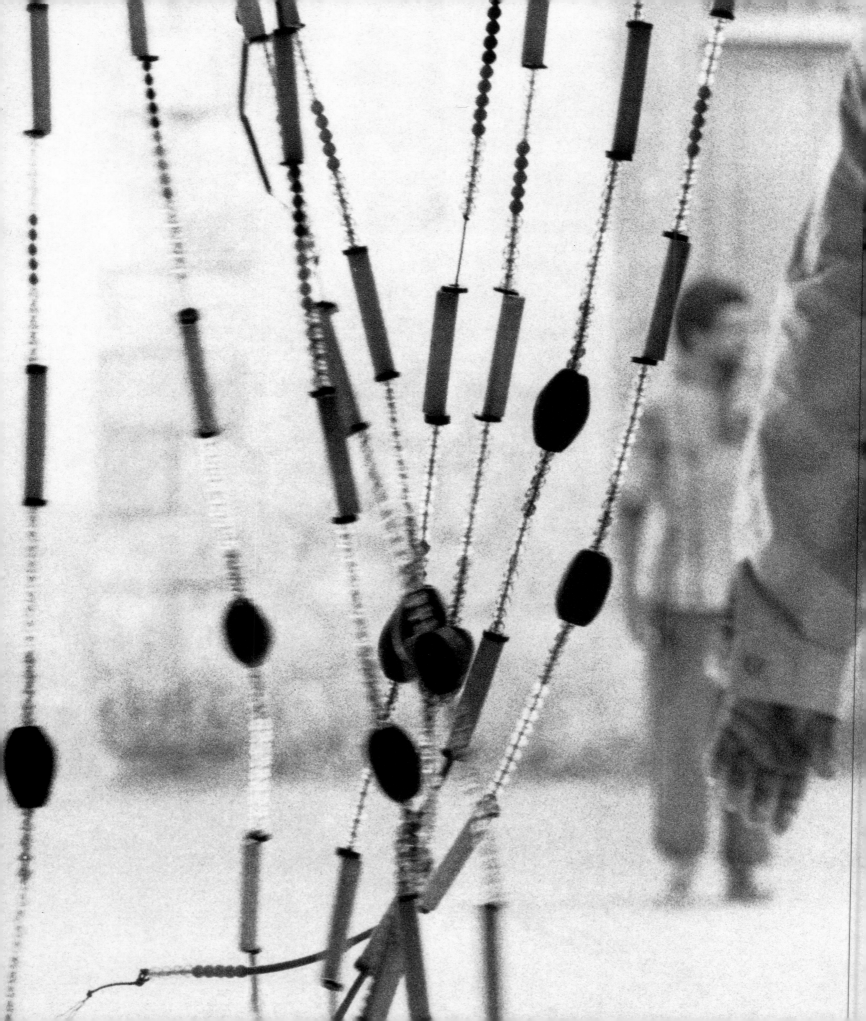

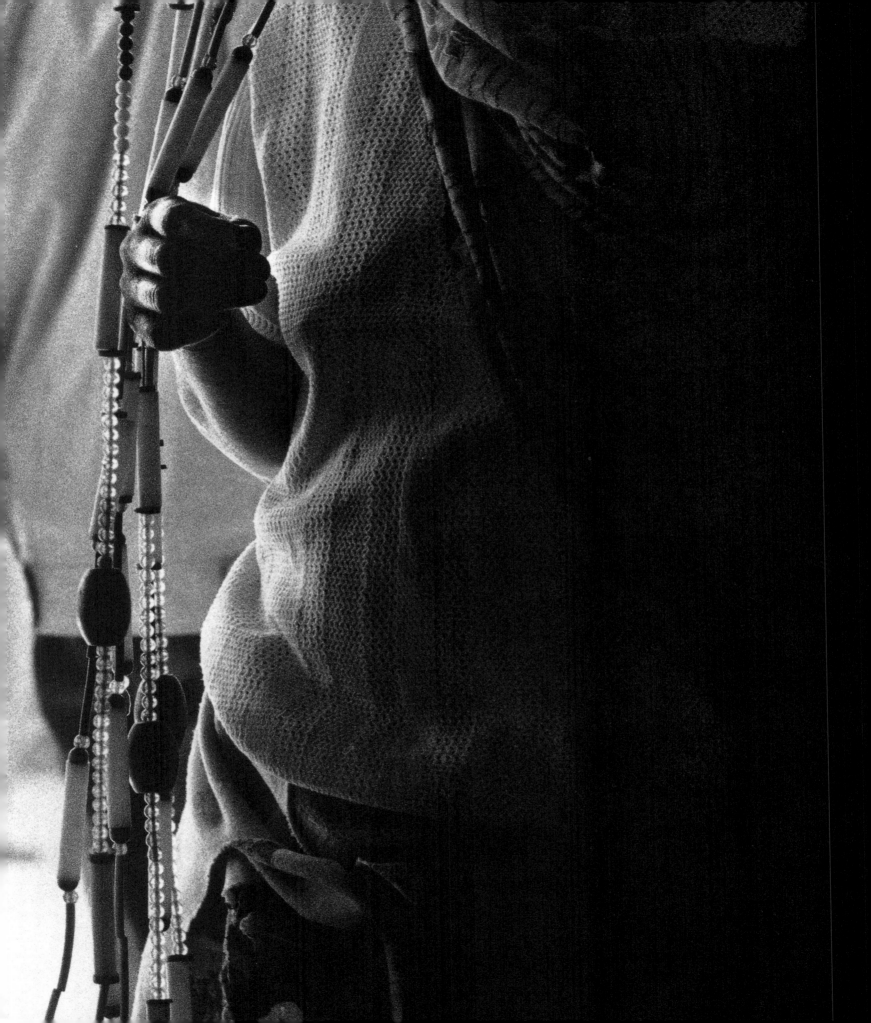

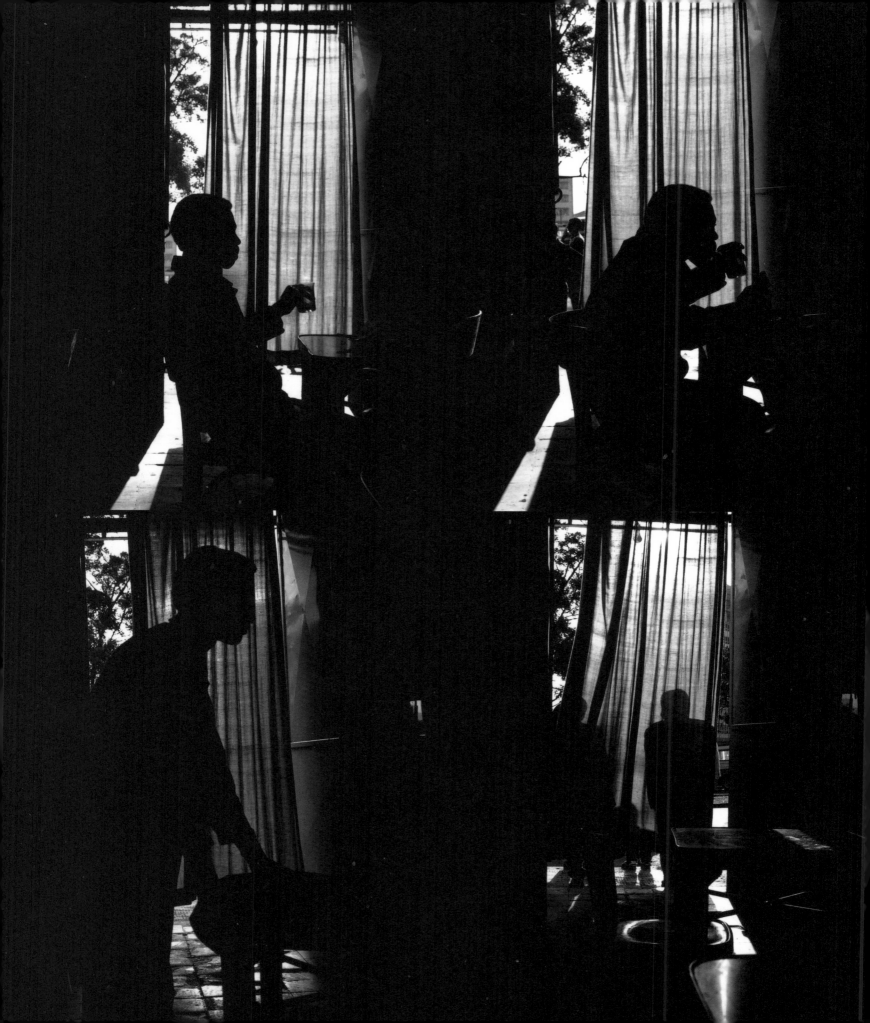

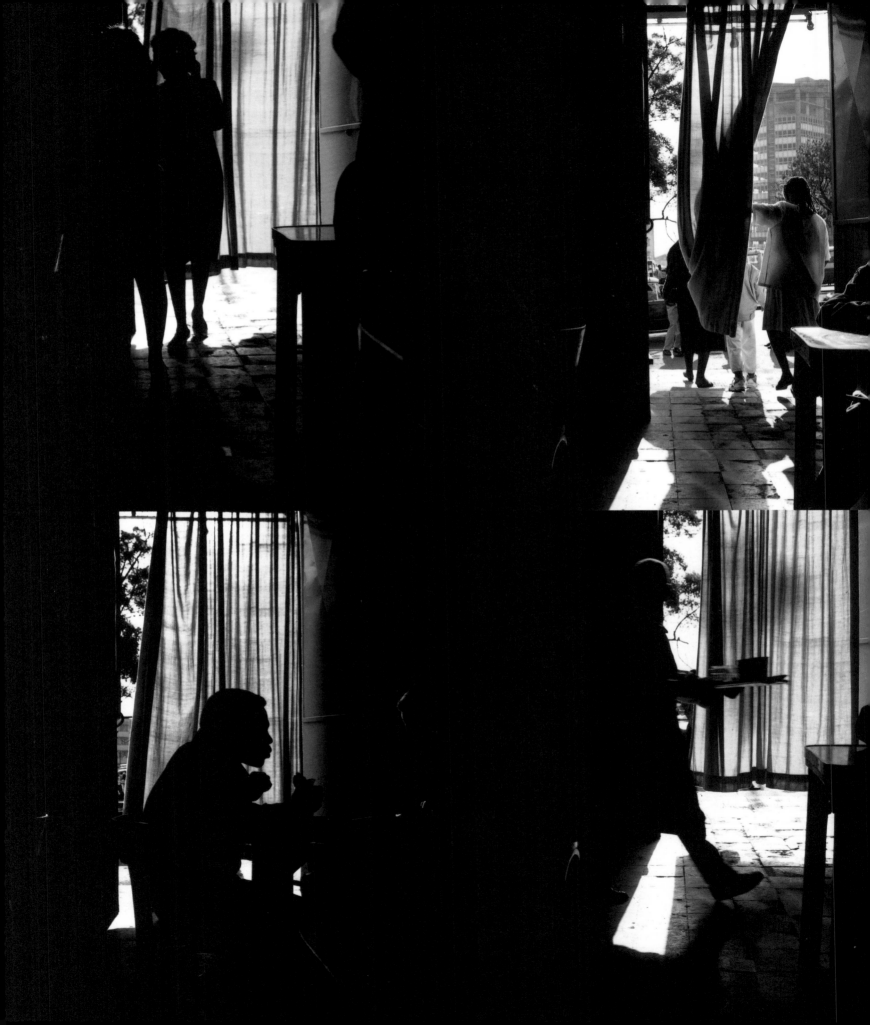

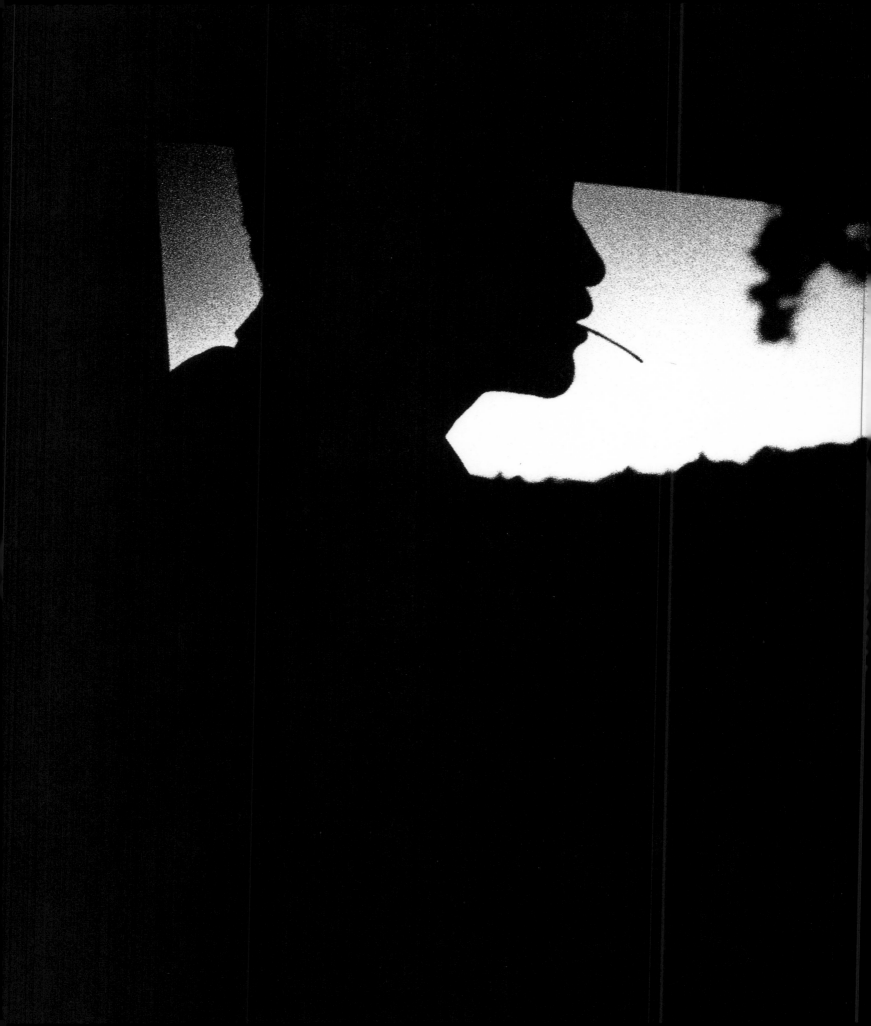

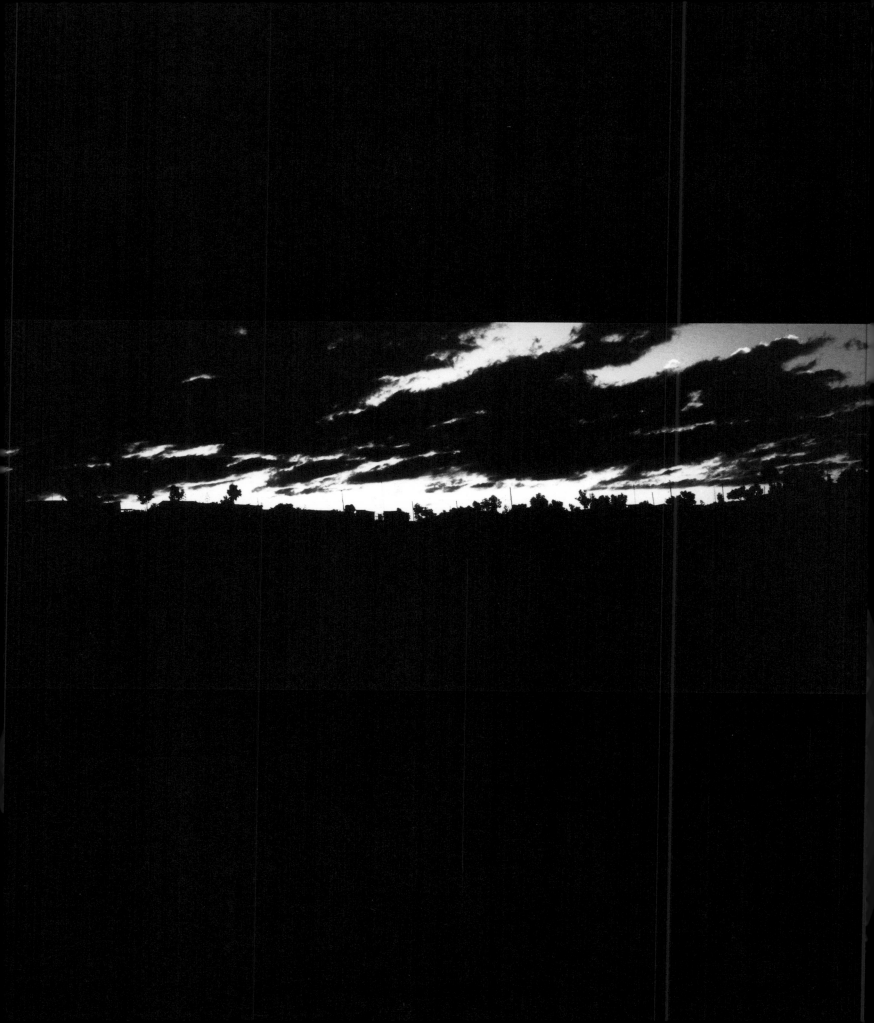

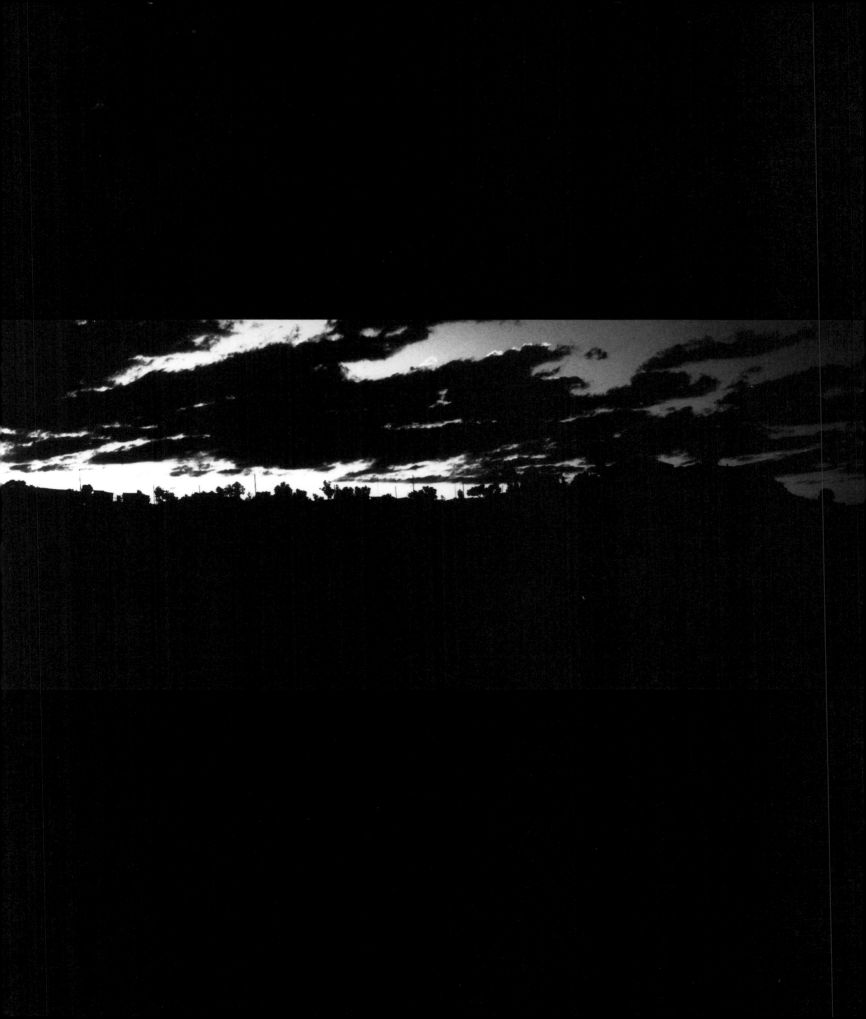

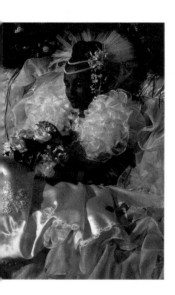

ALEMSHAYE I

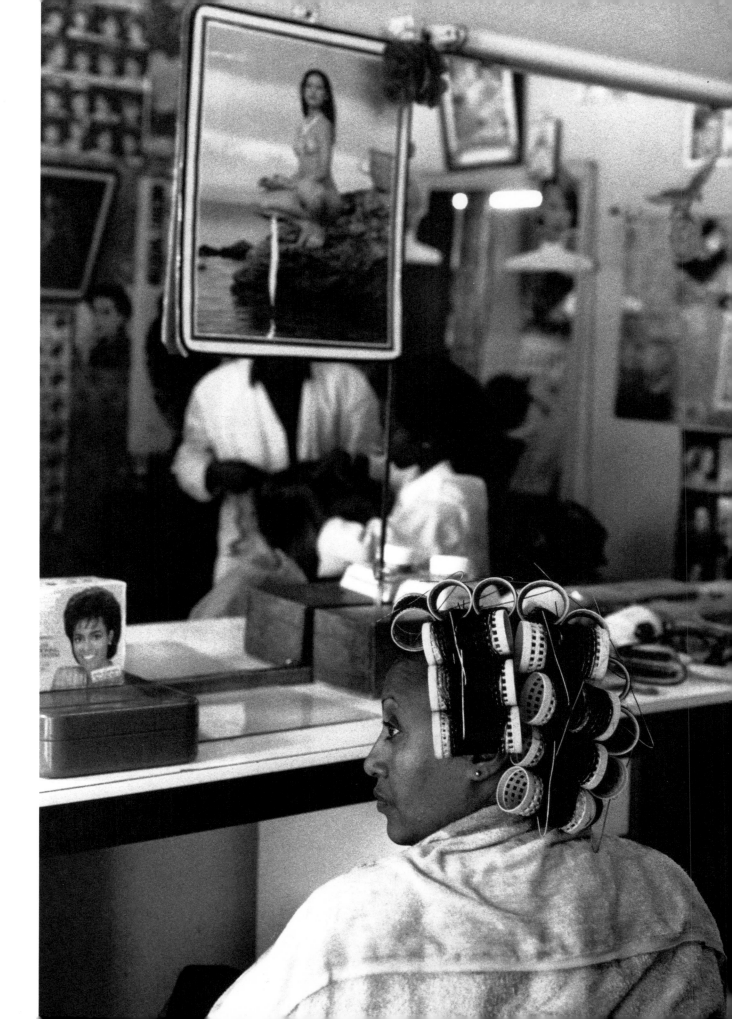

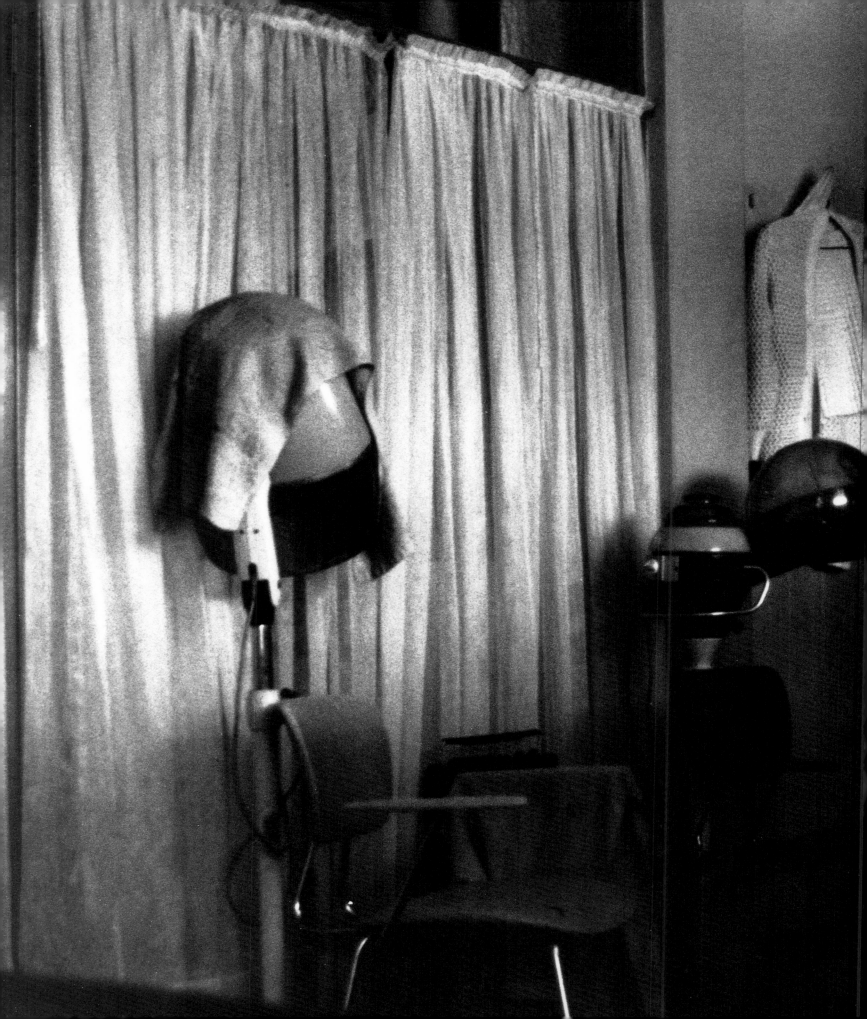

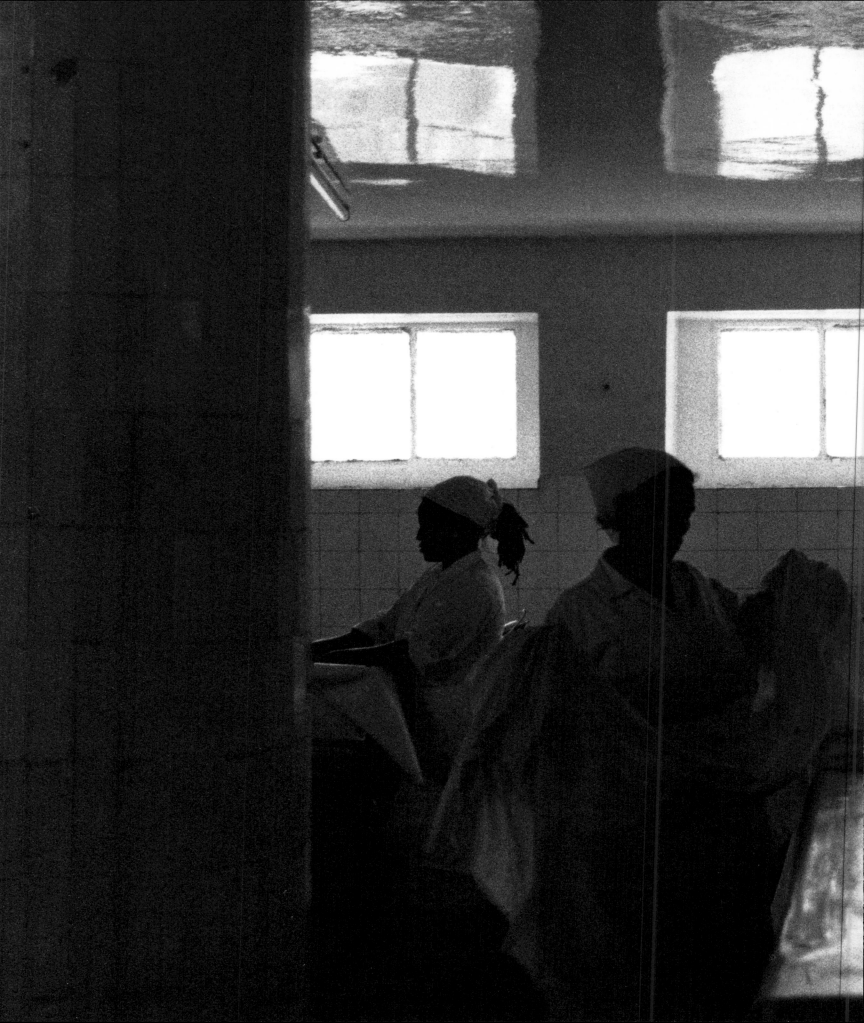

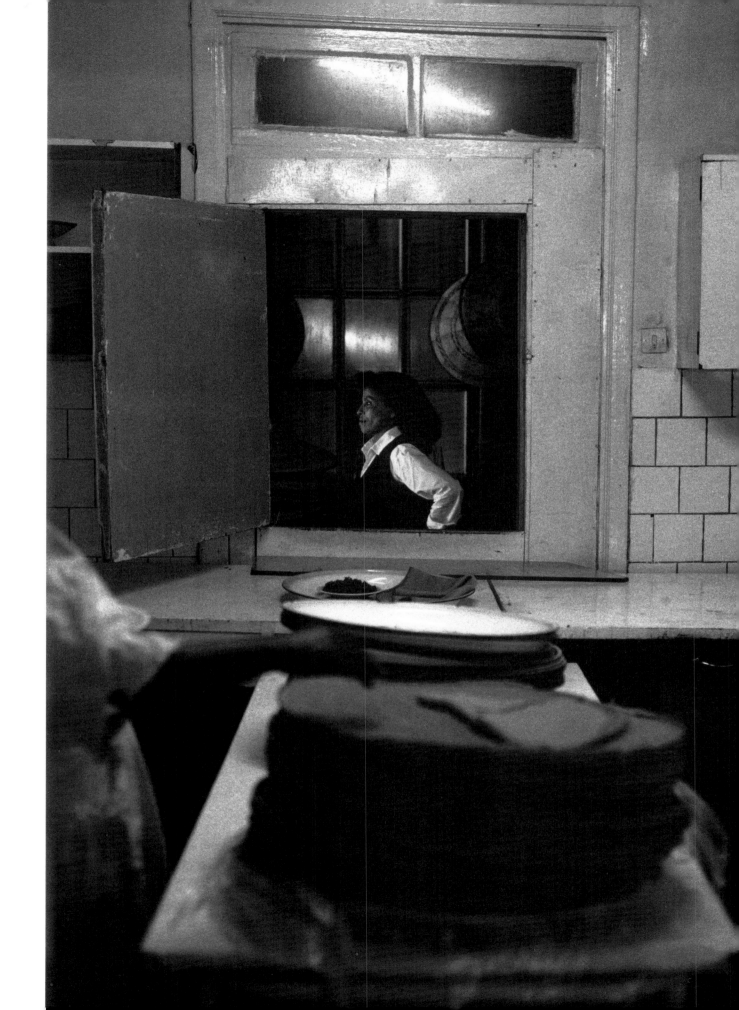

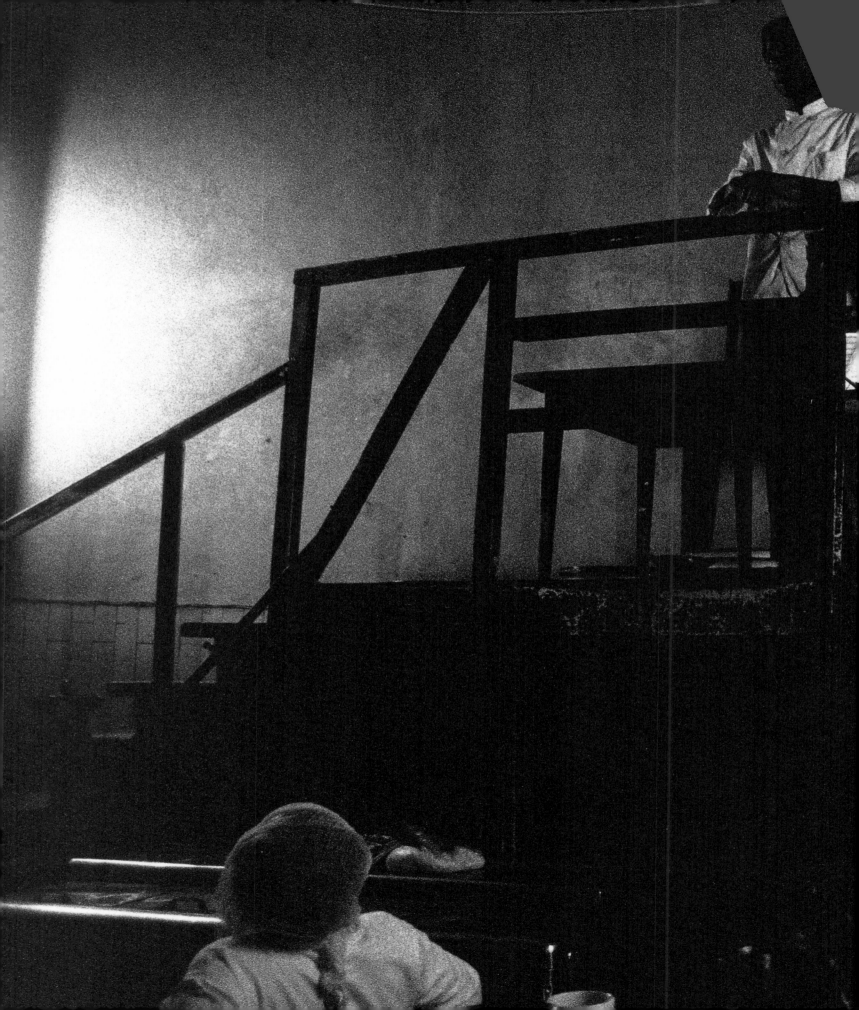

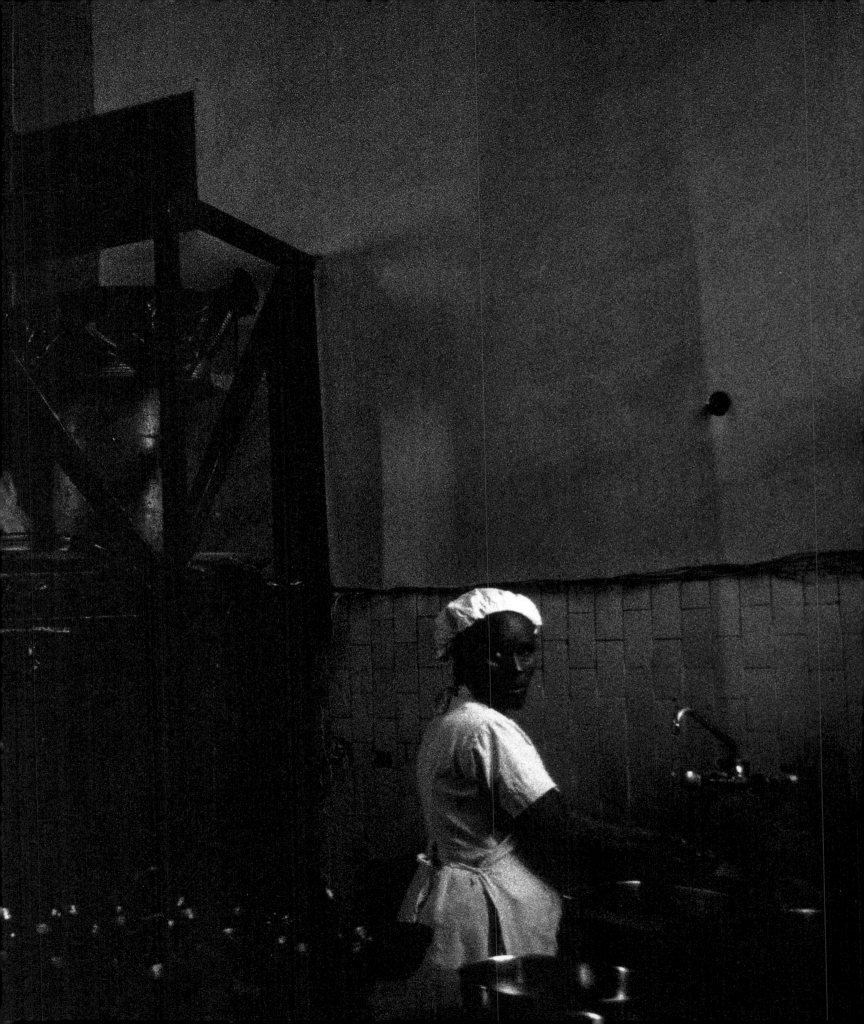

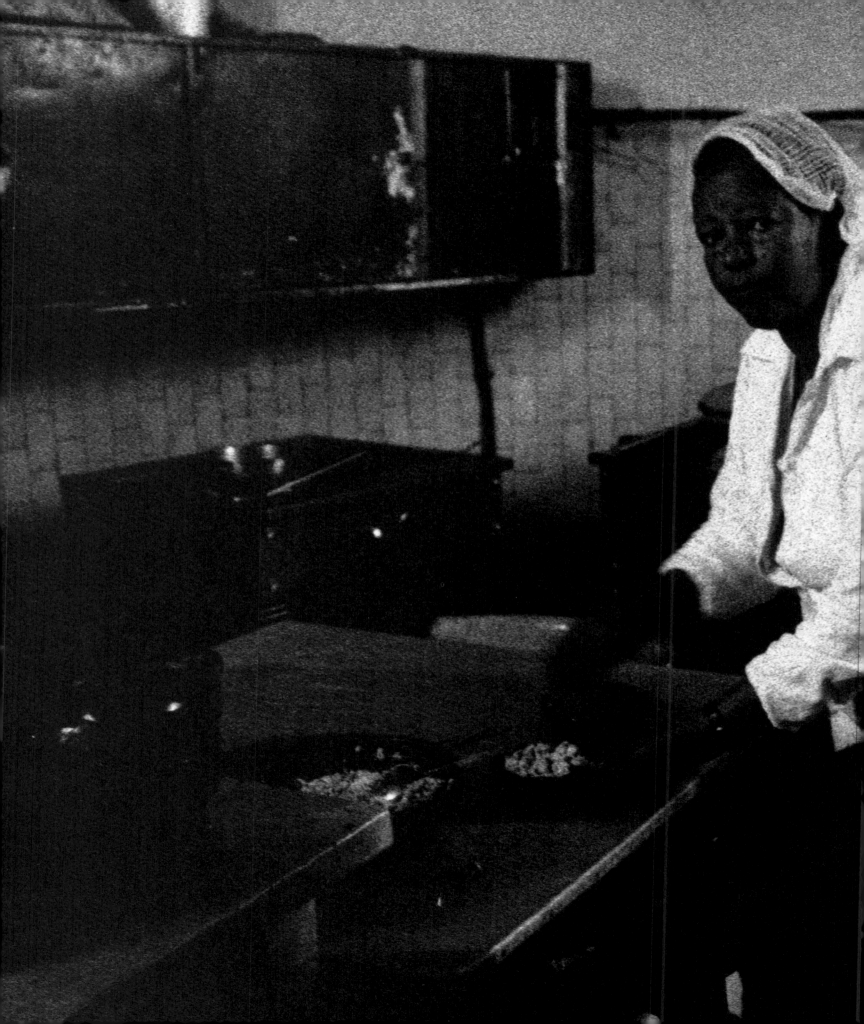

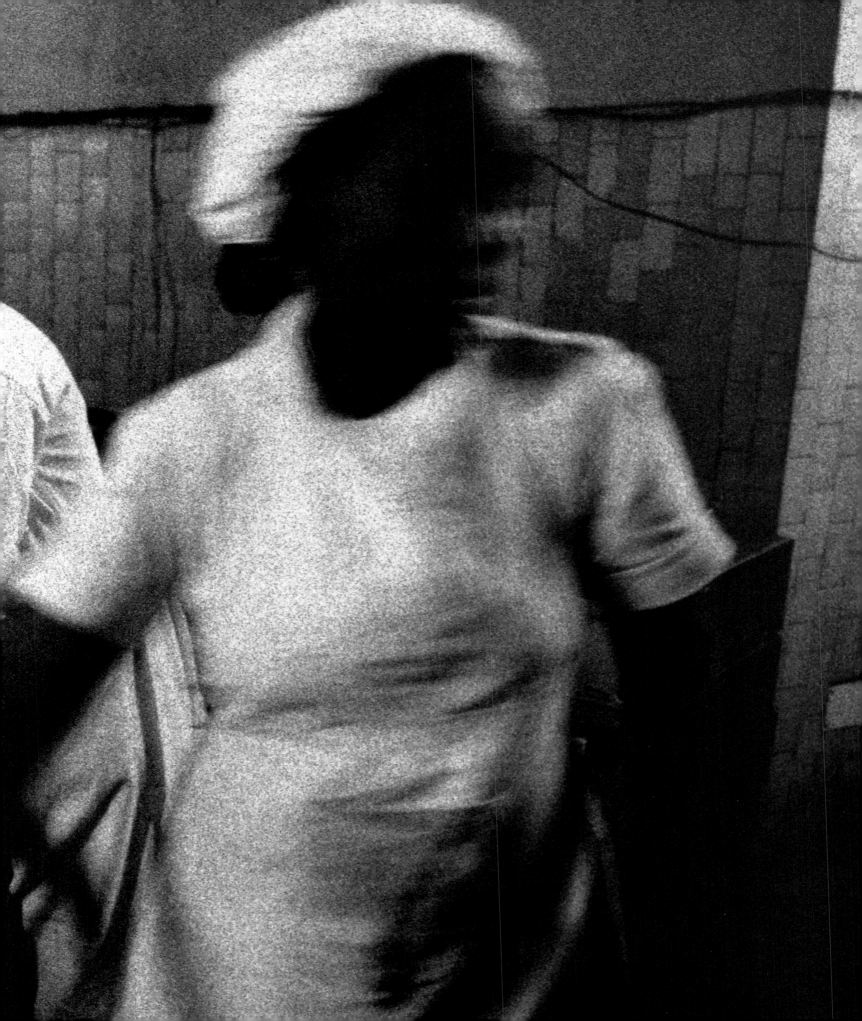

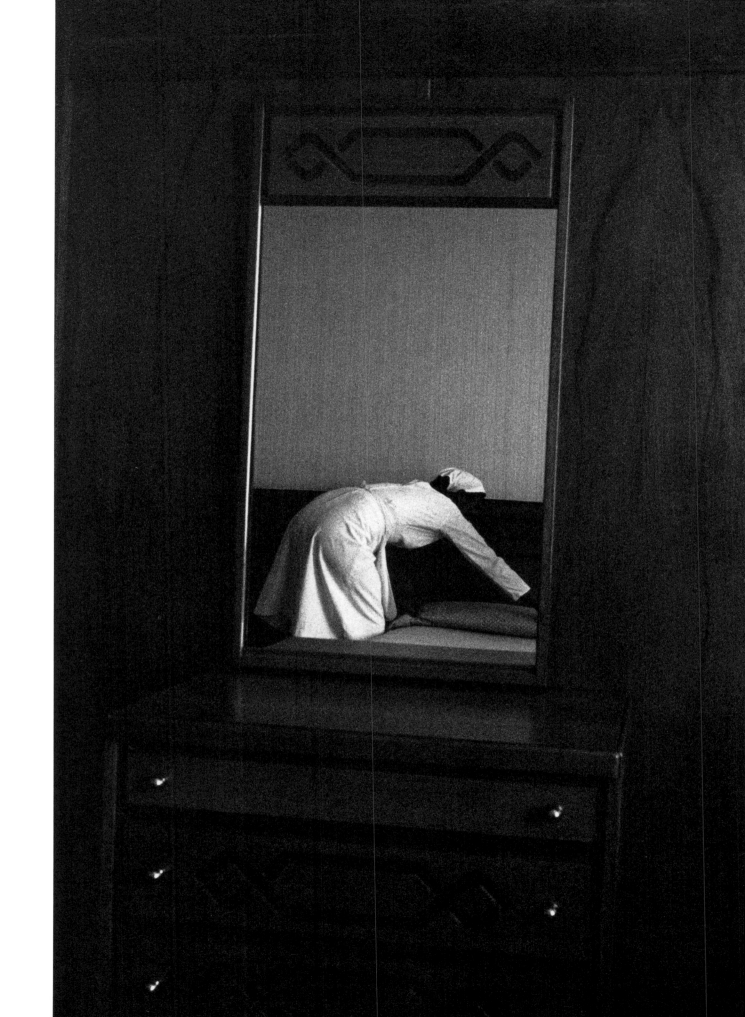

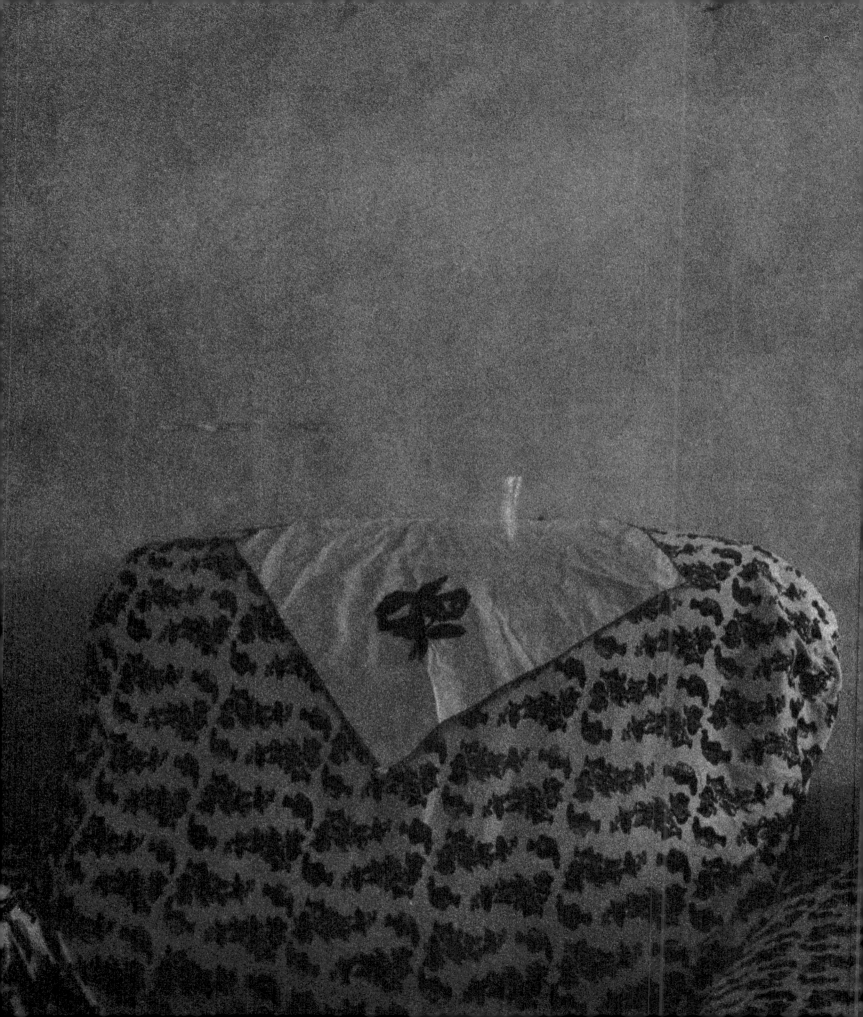

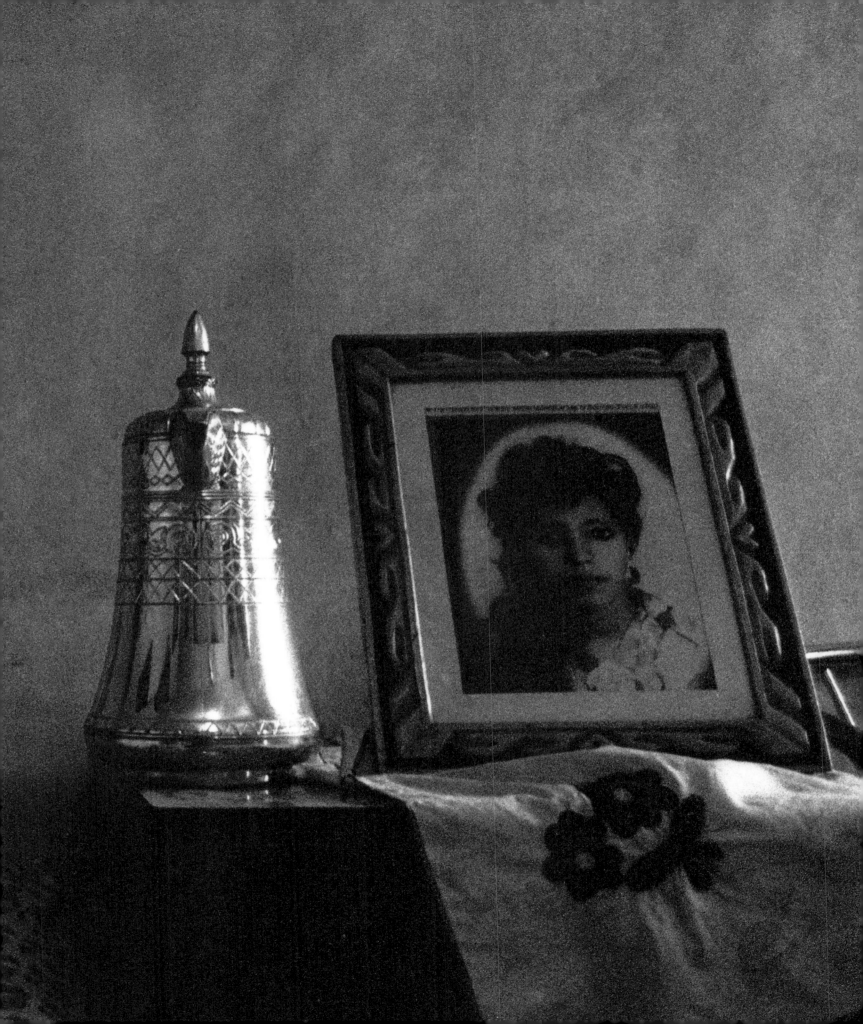

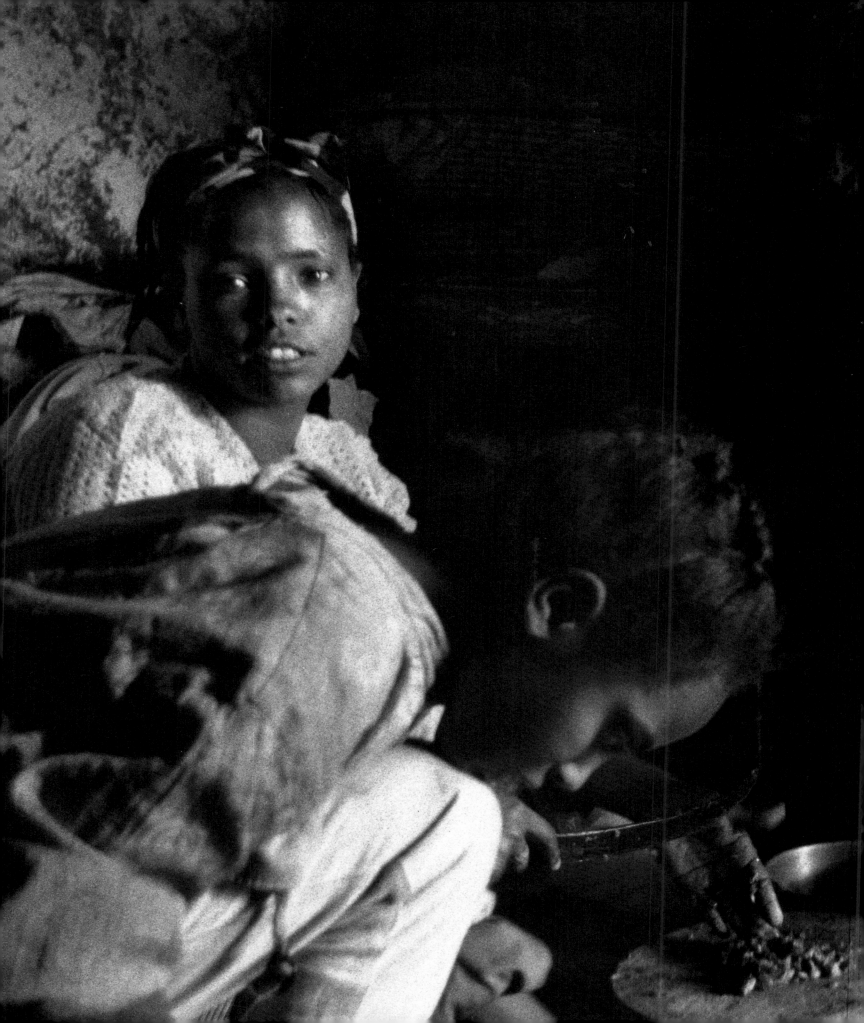

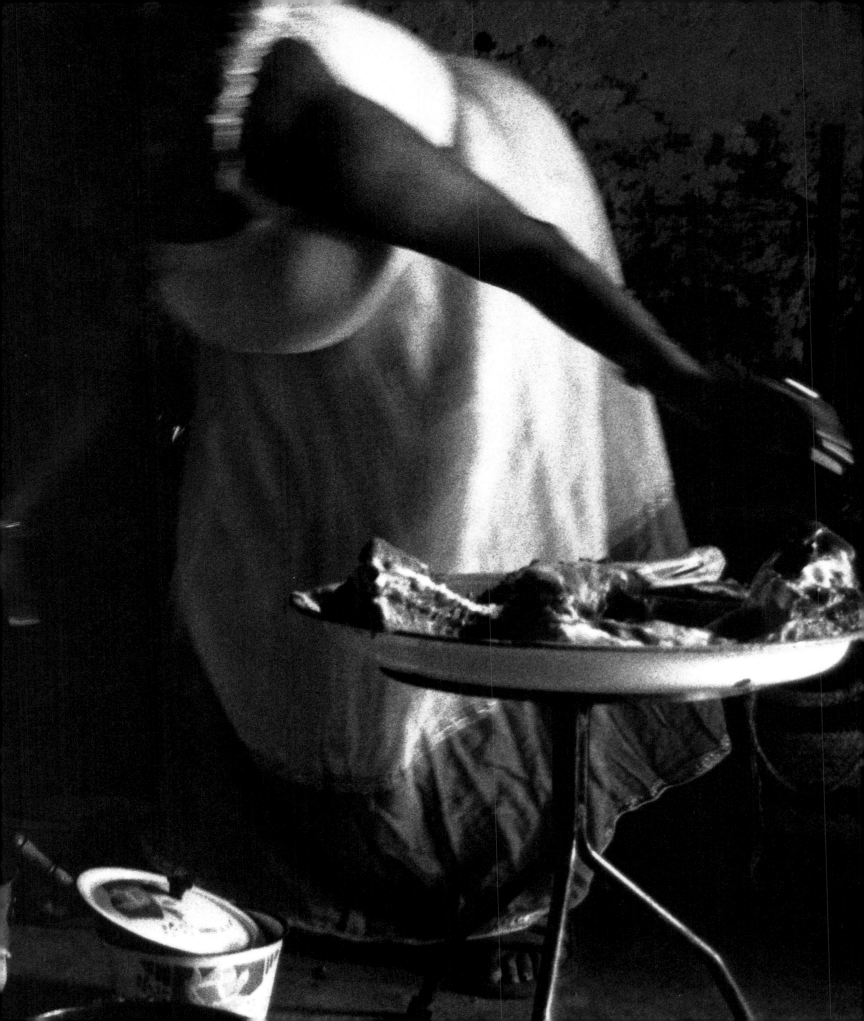

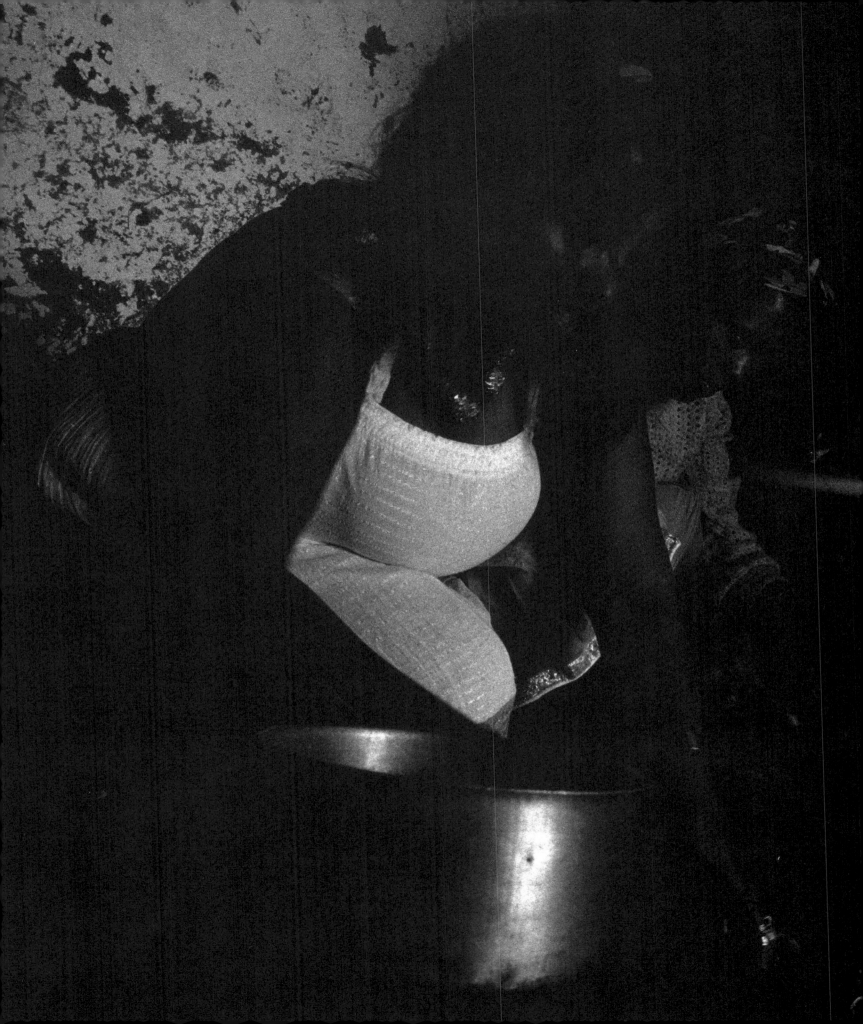

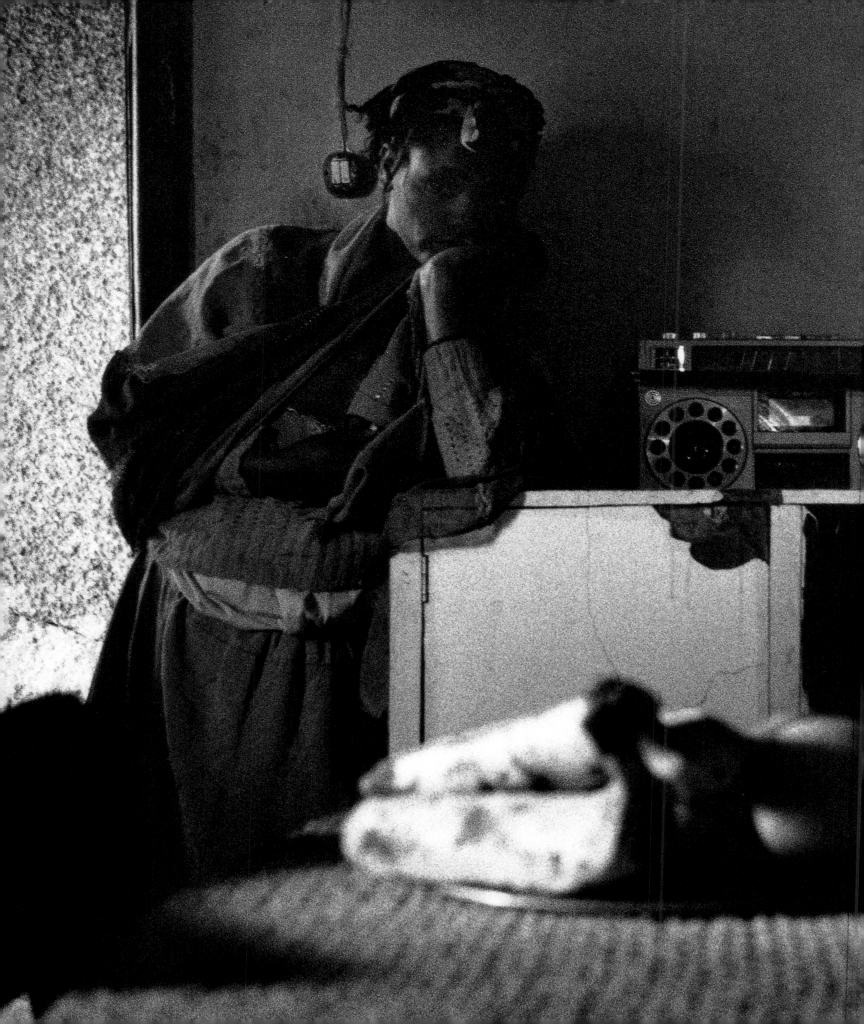

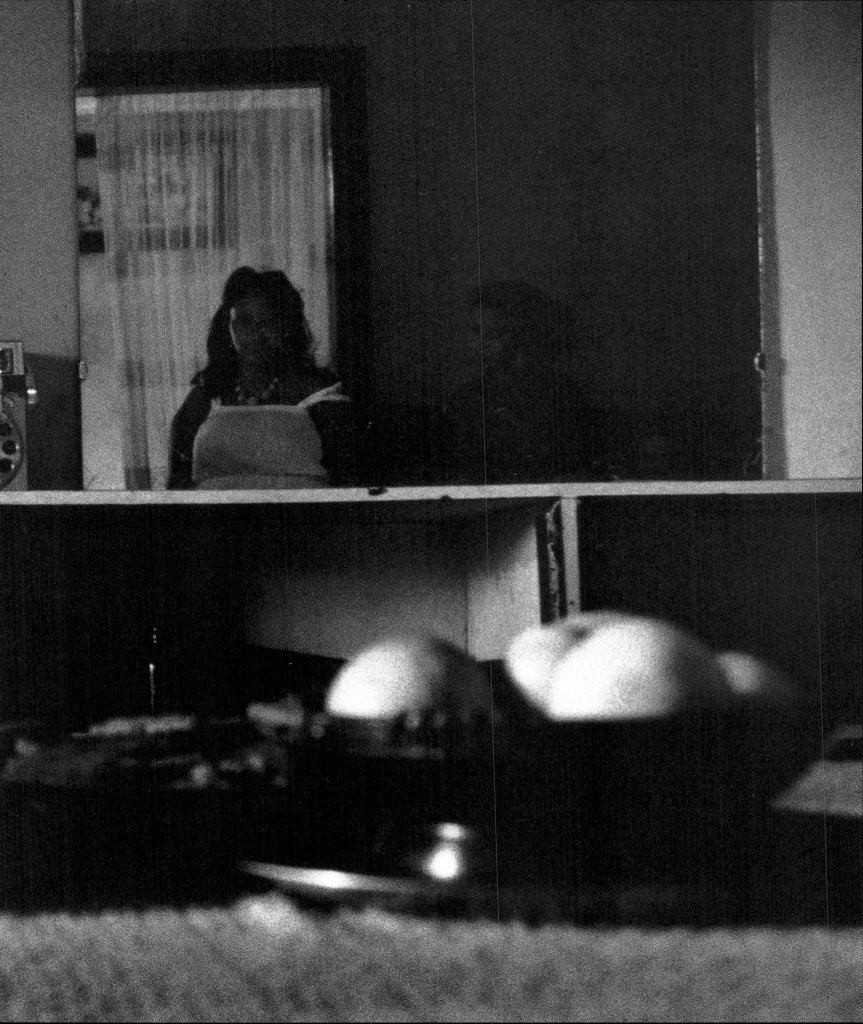

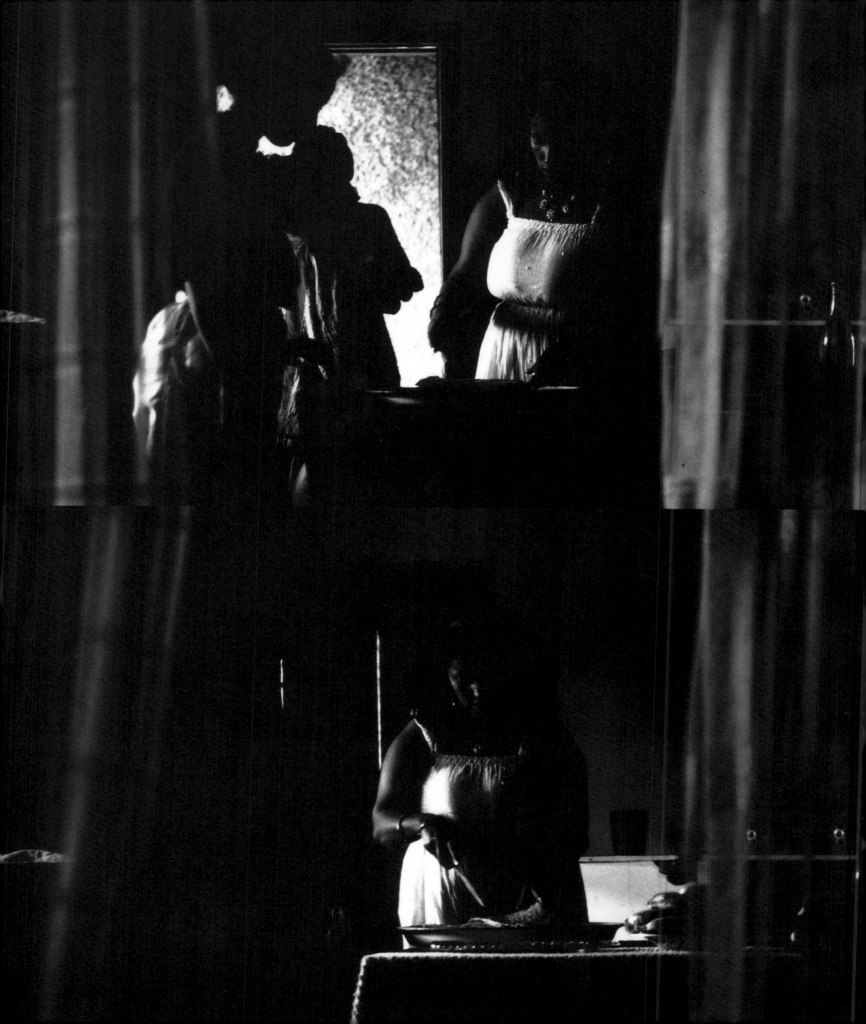

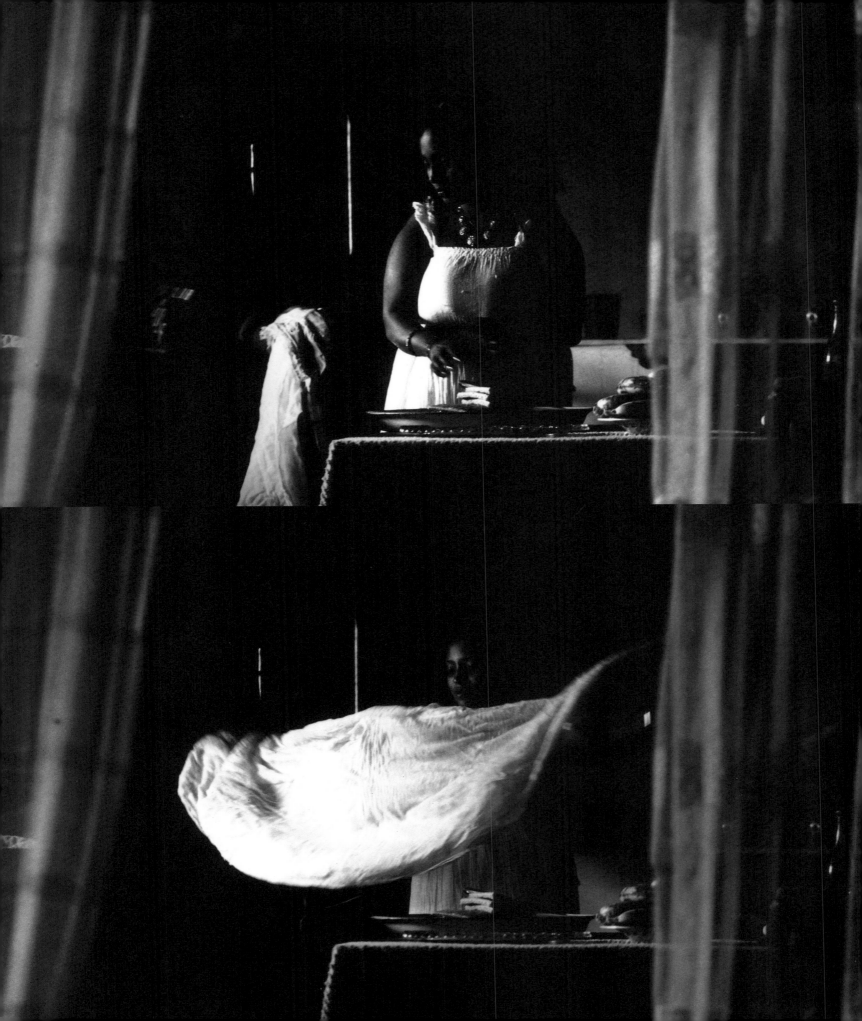

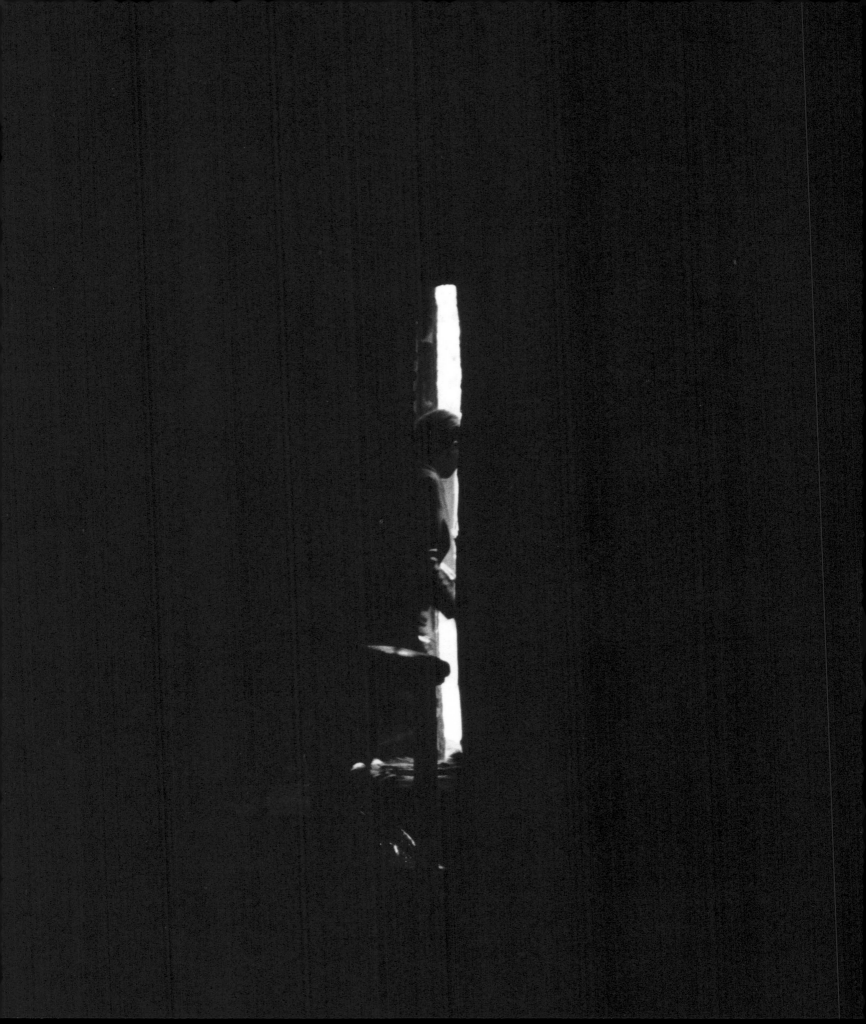

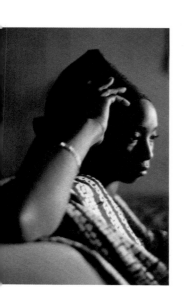

PENDA 2

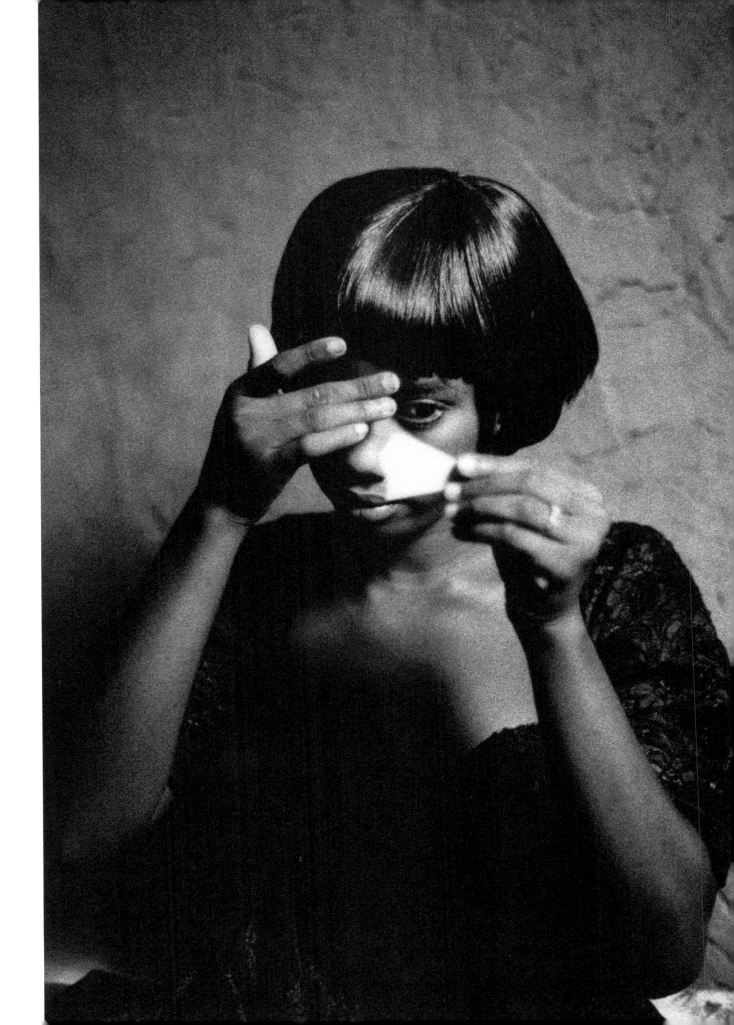

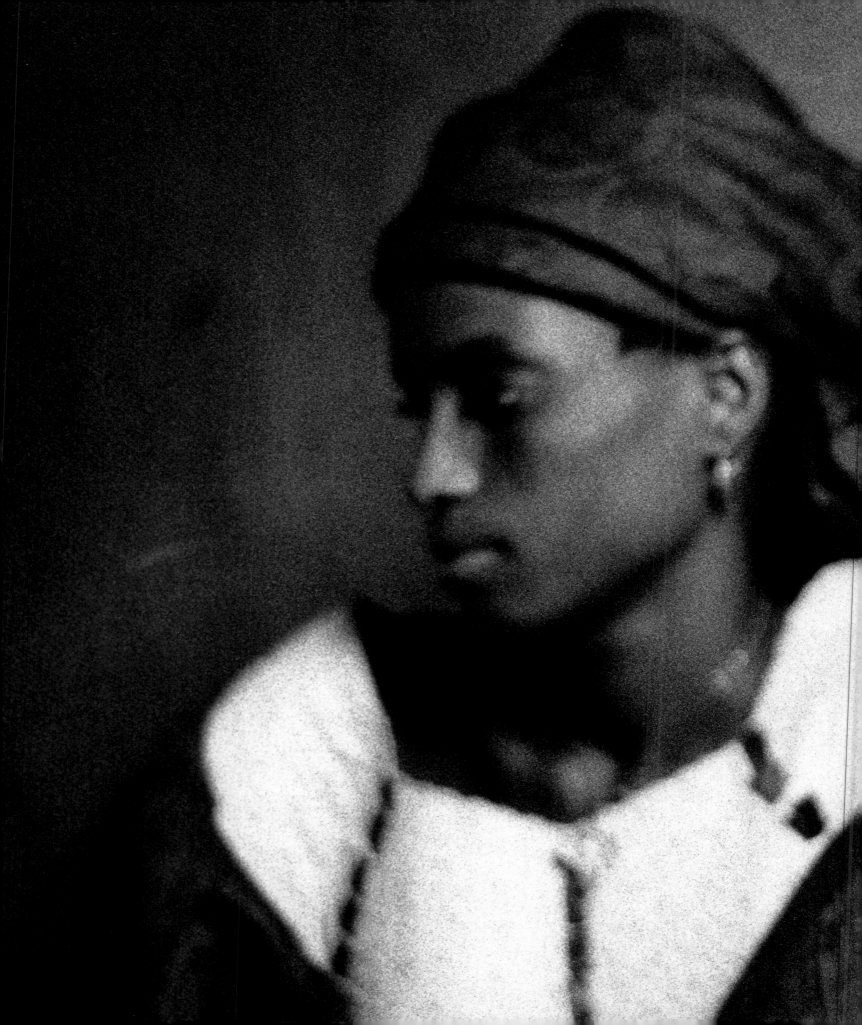

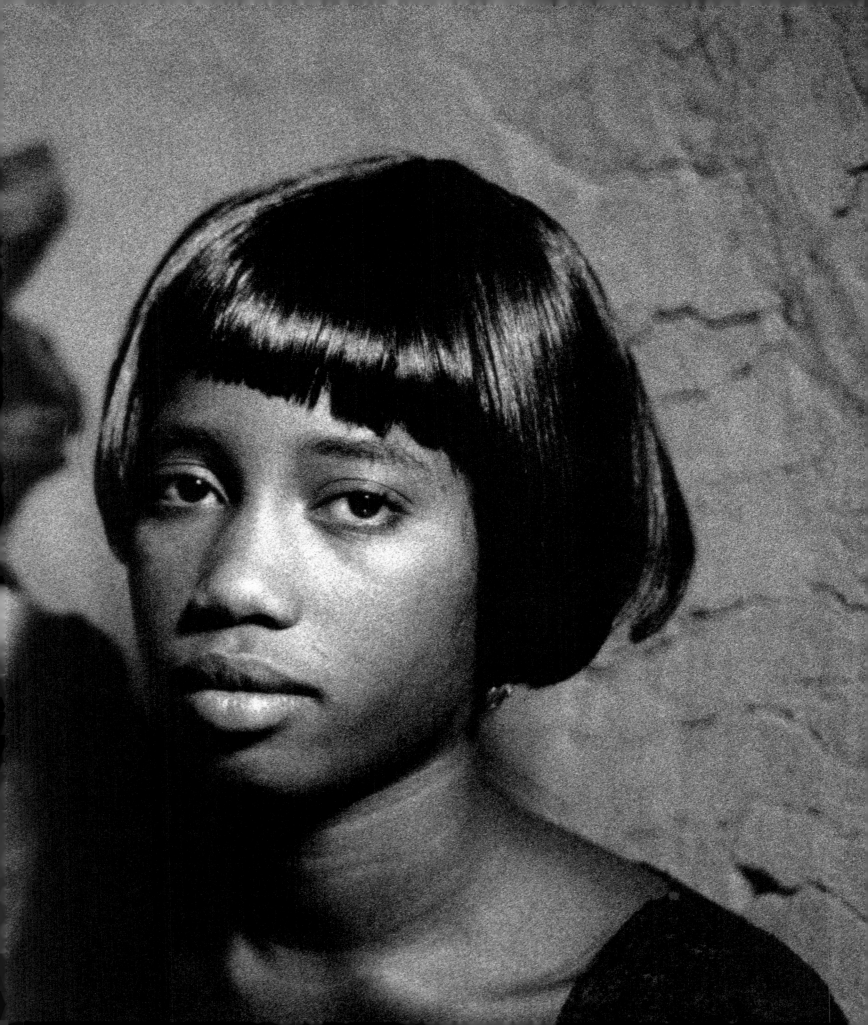

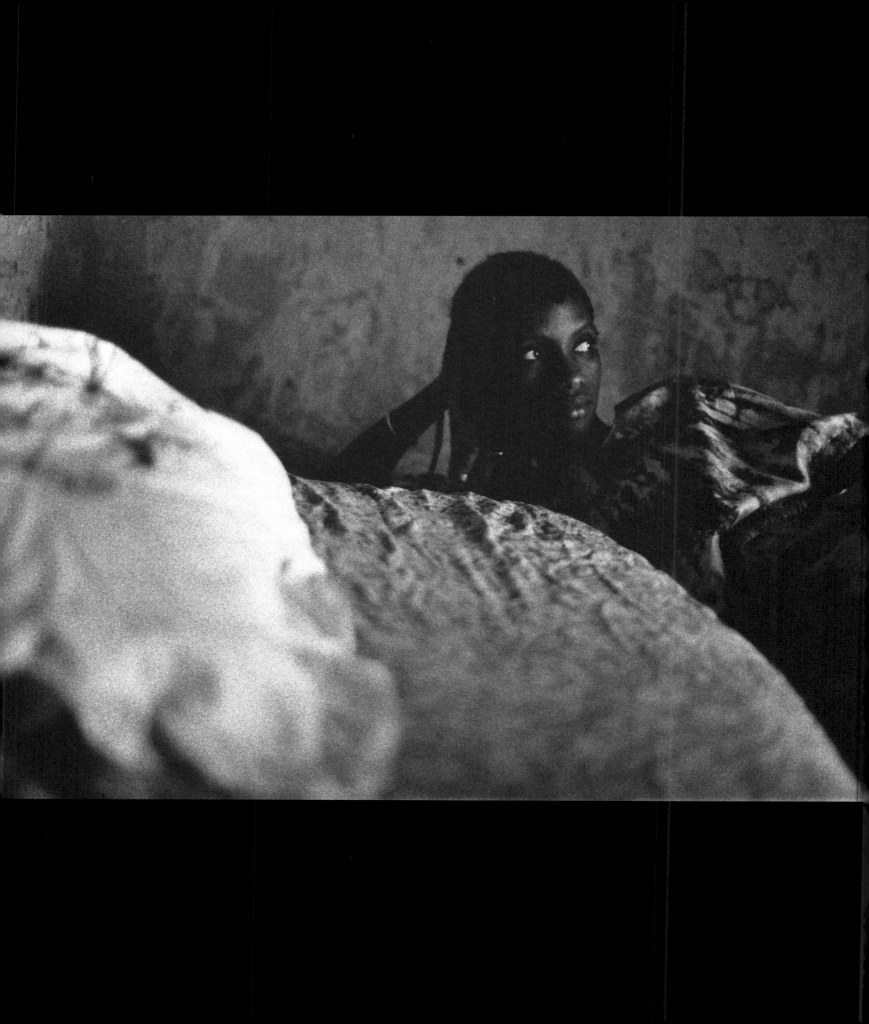

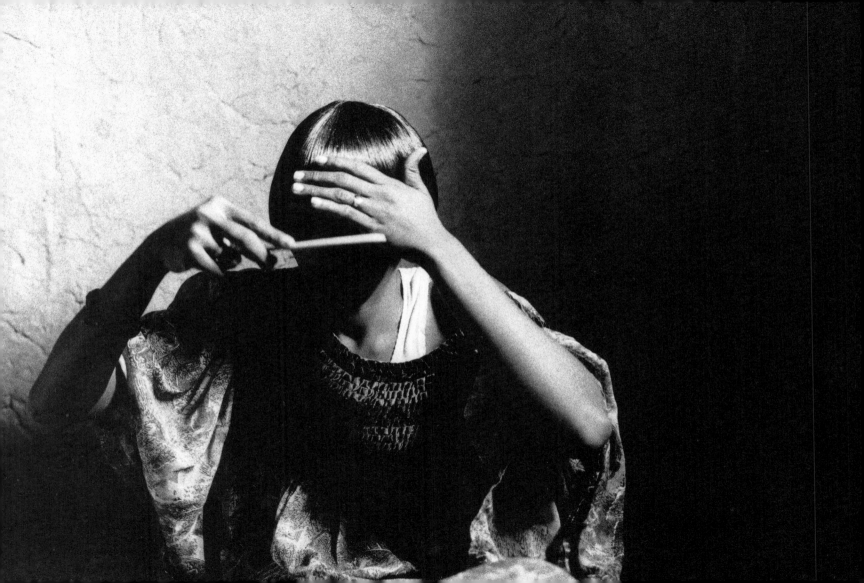

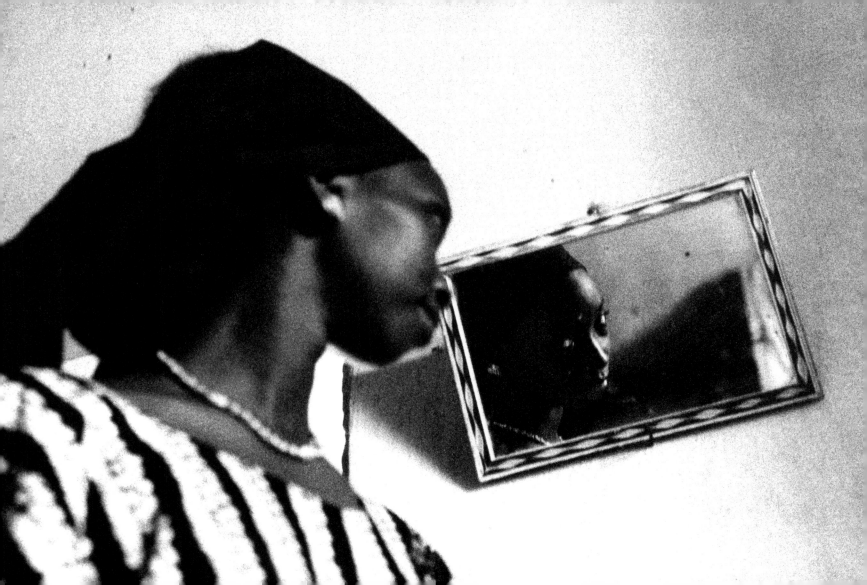

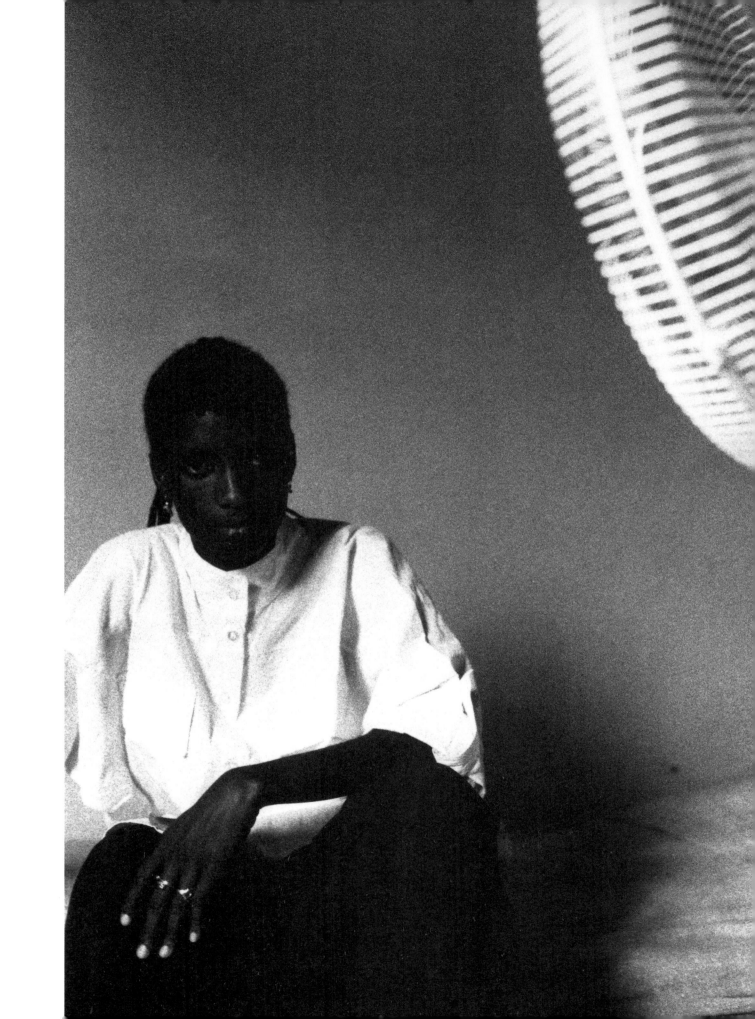

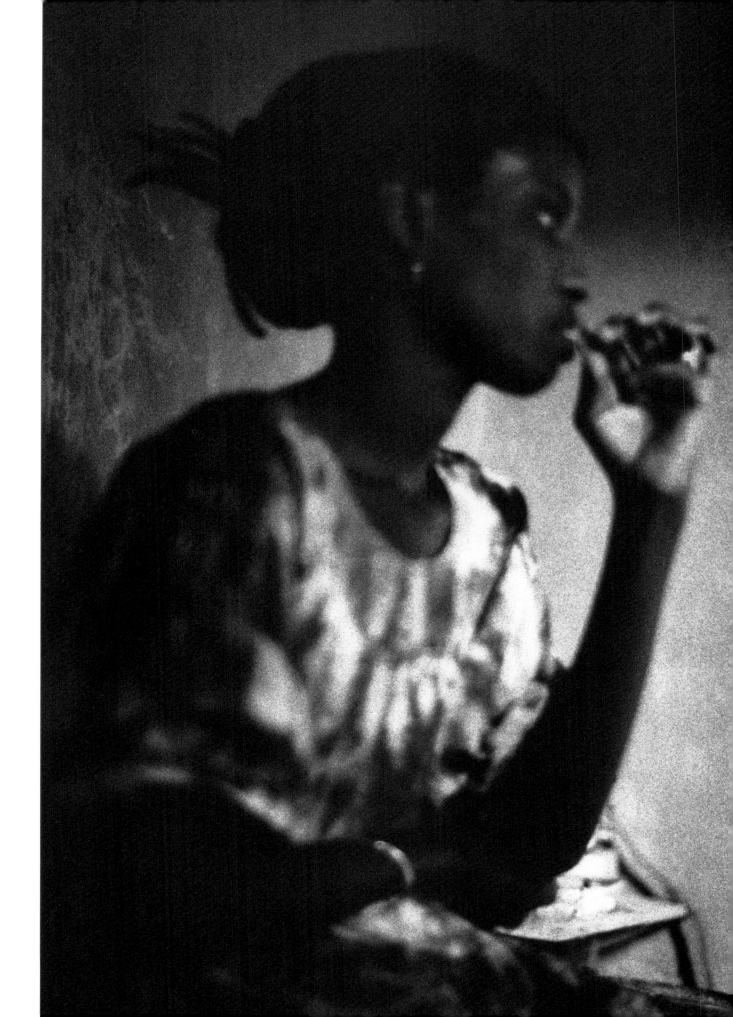

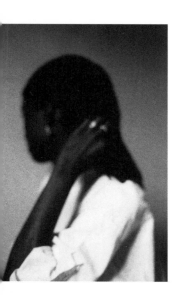

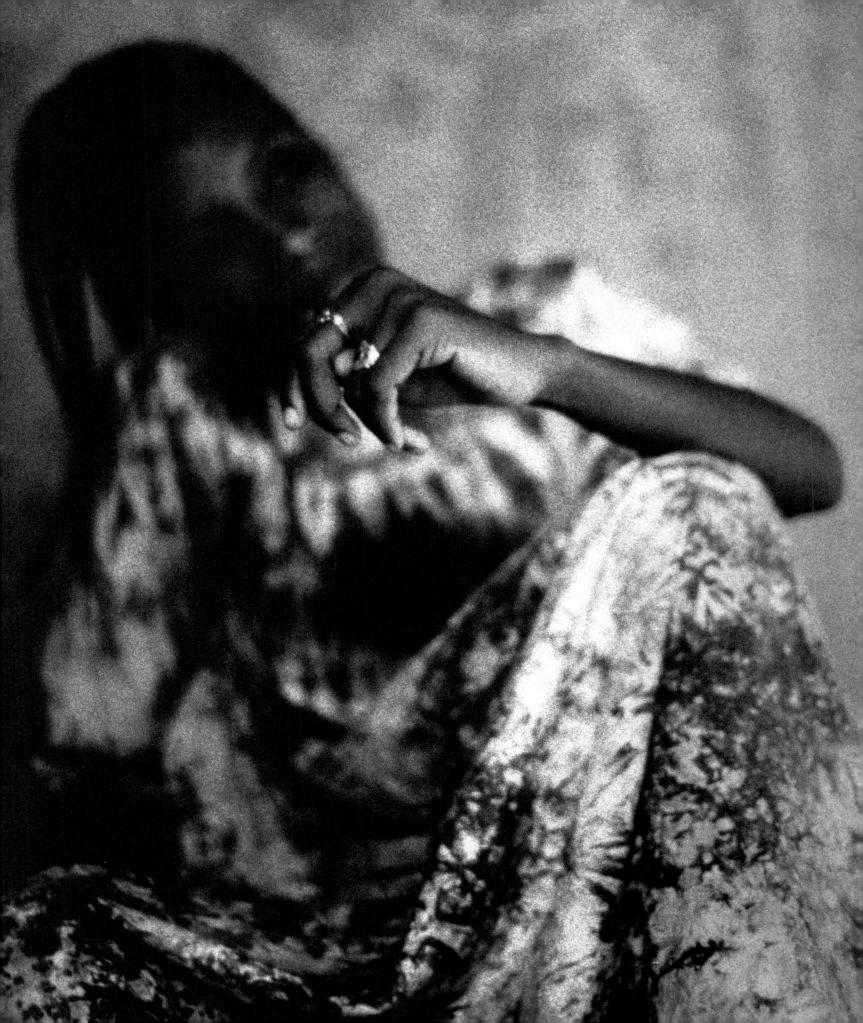

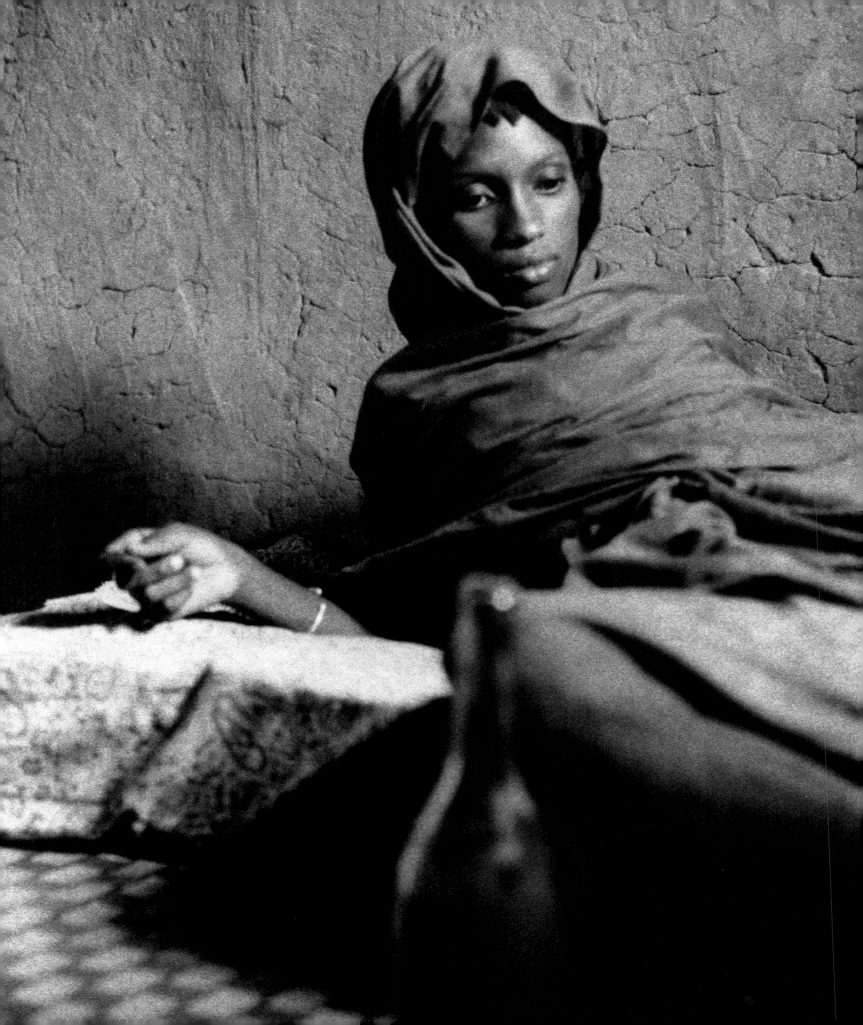

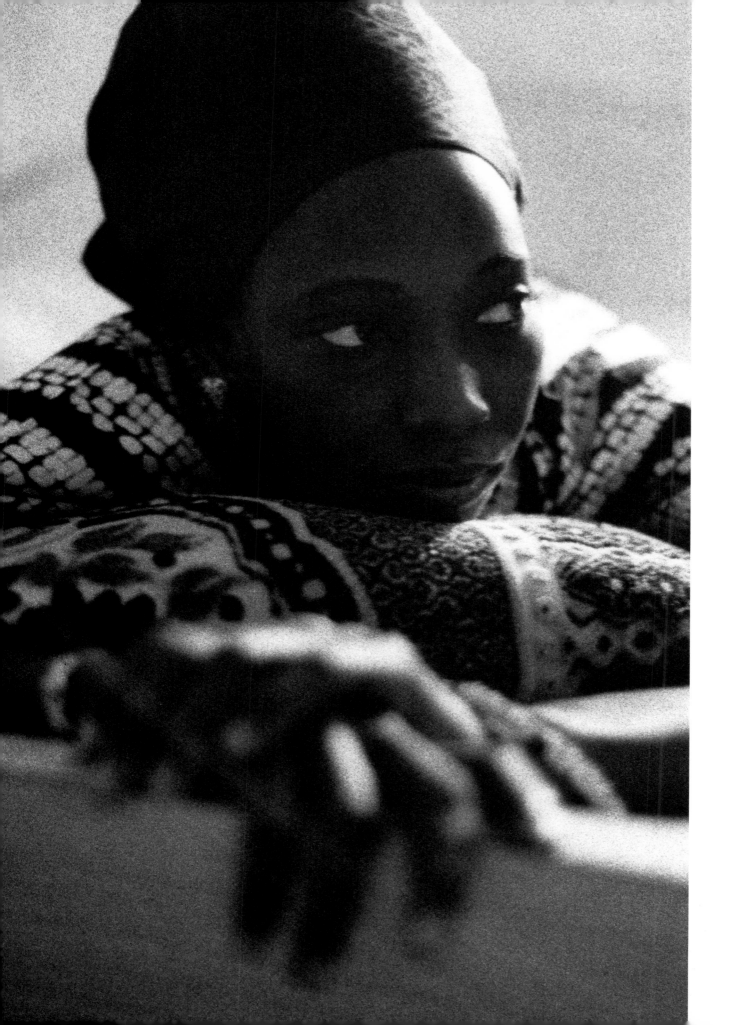

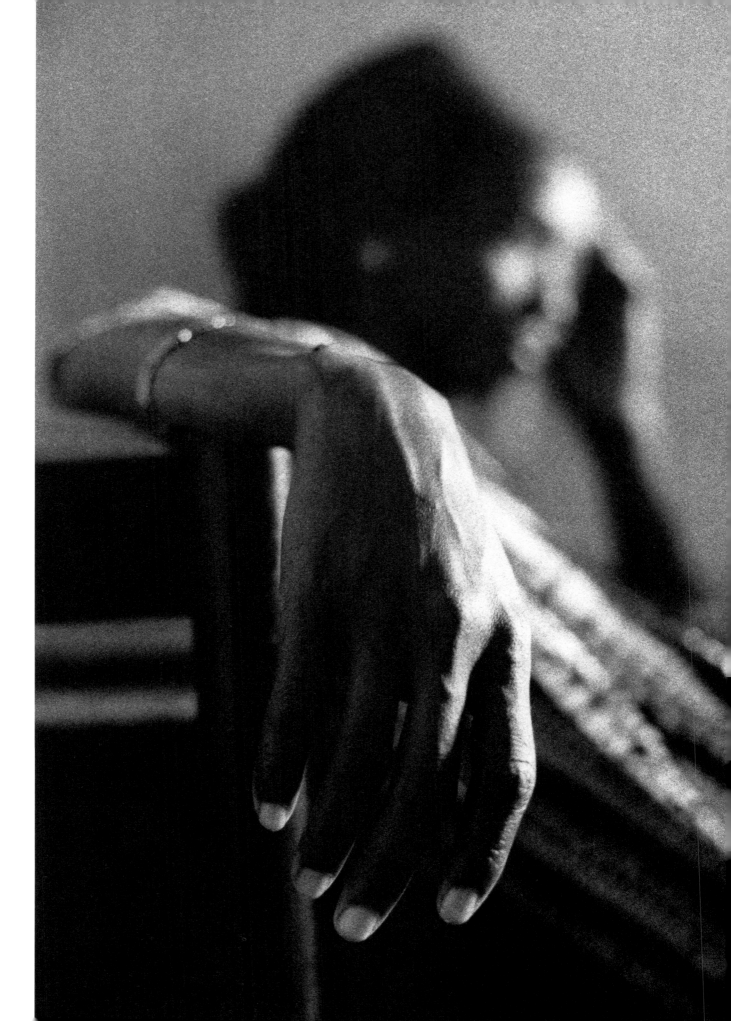

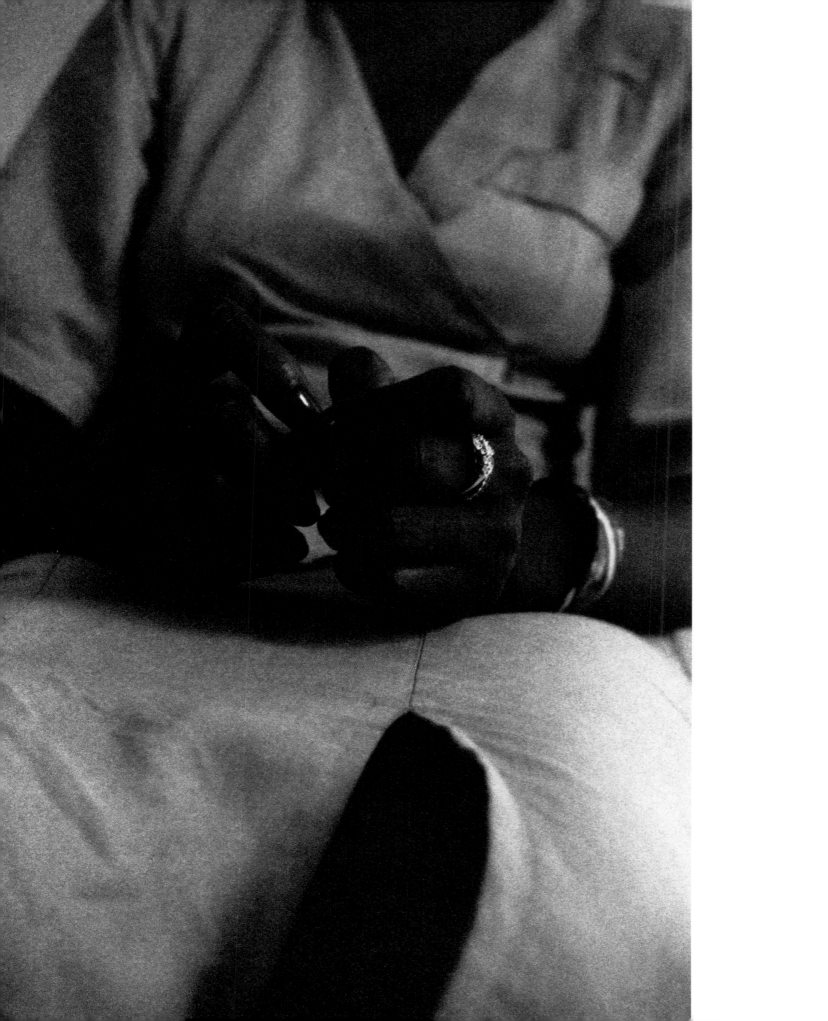

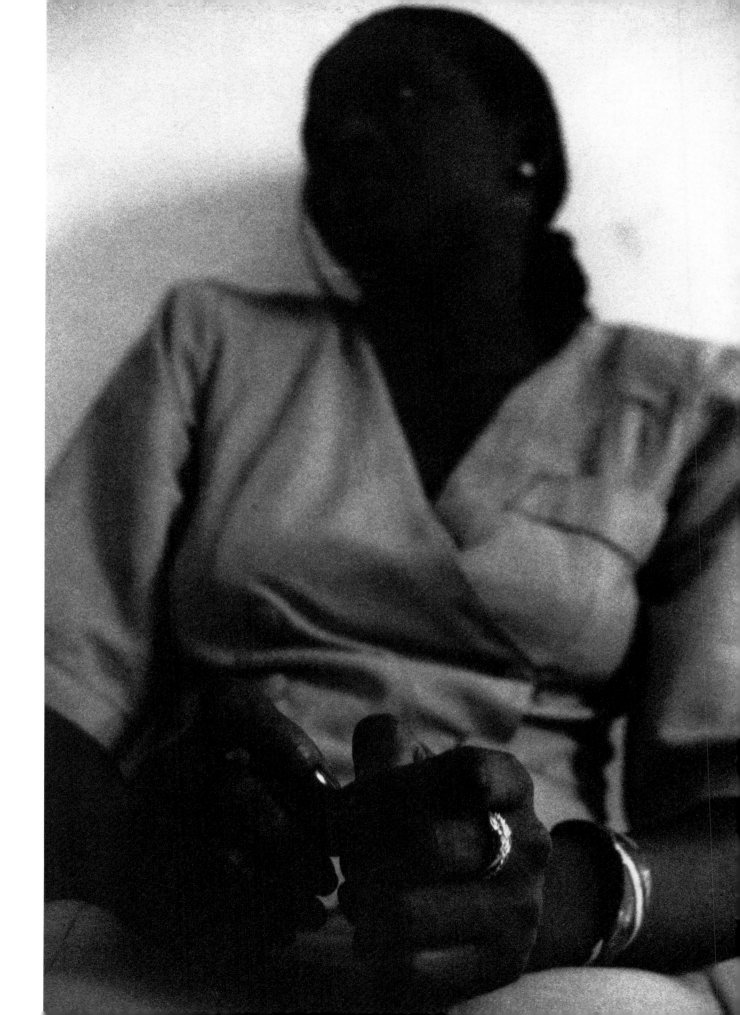

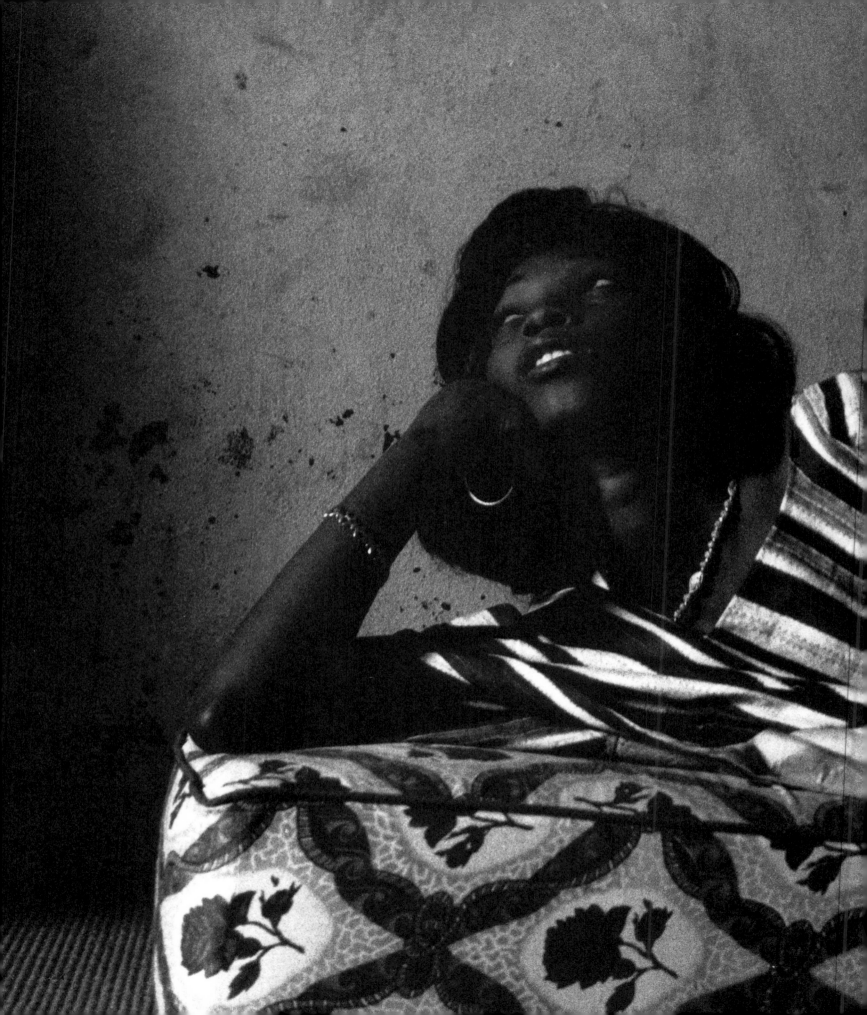

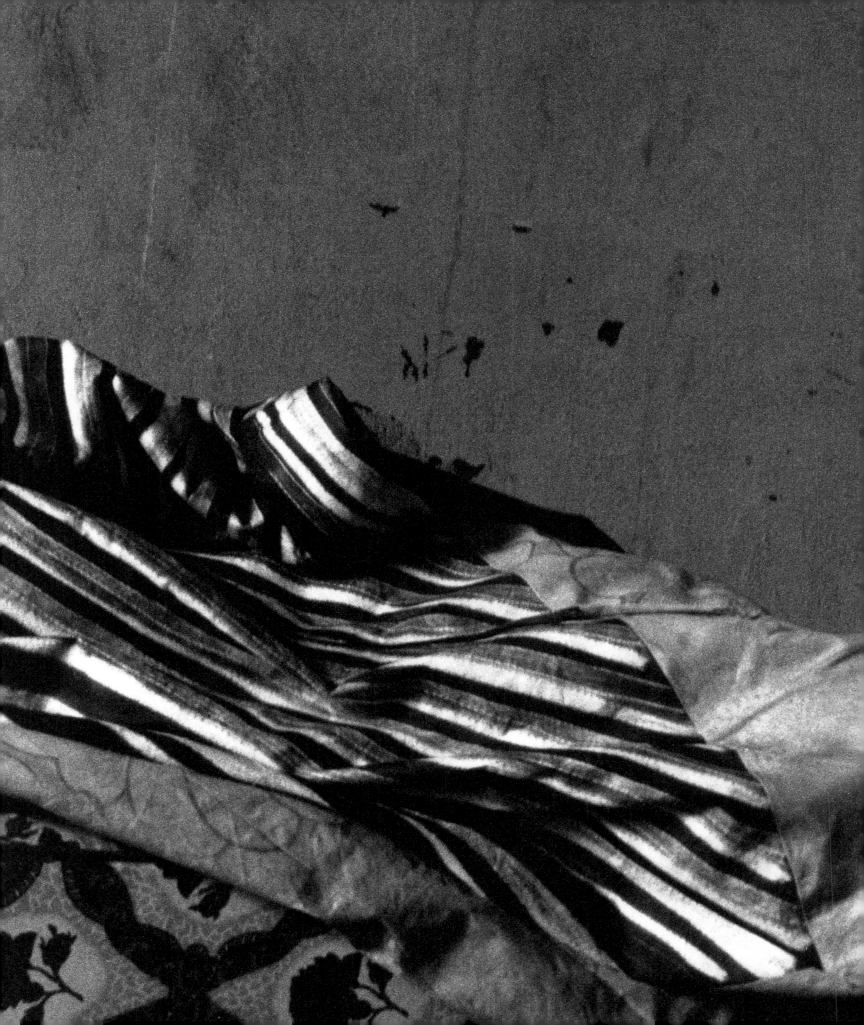

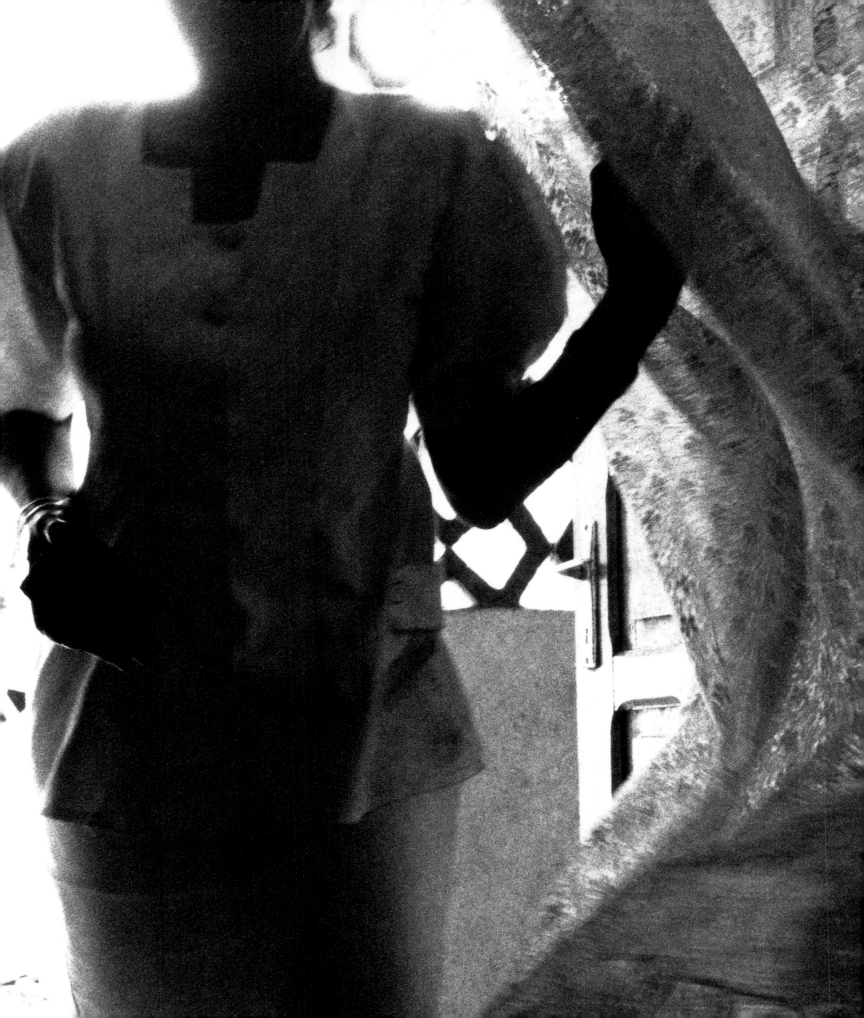

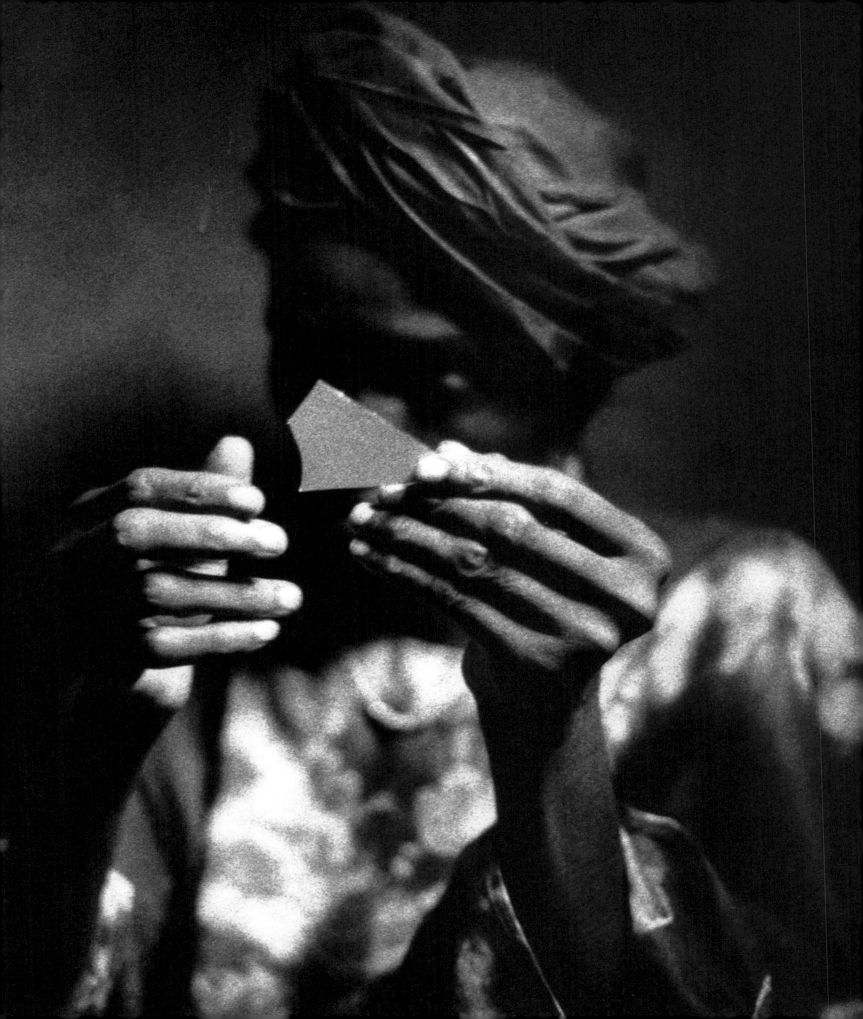

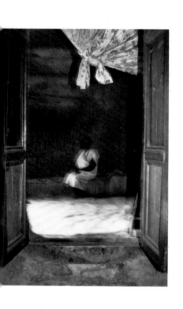

MARIAM 3

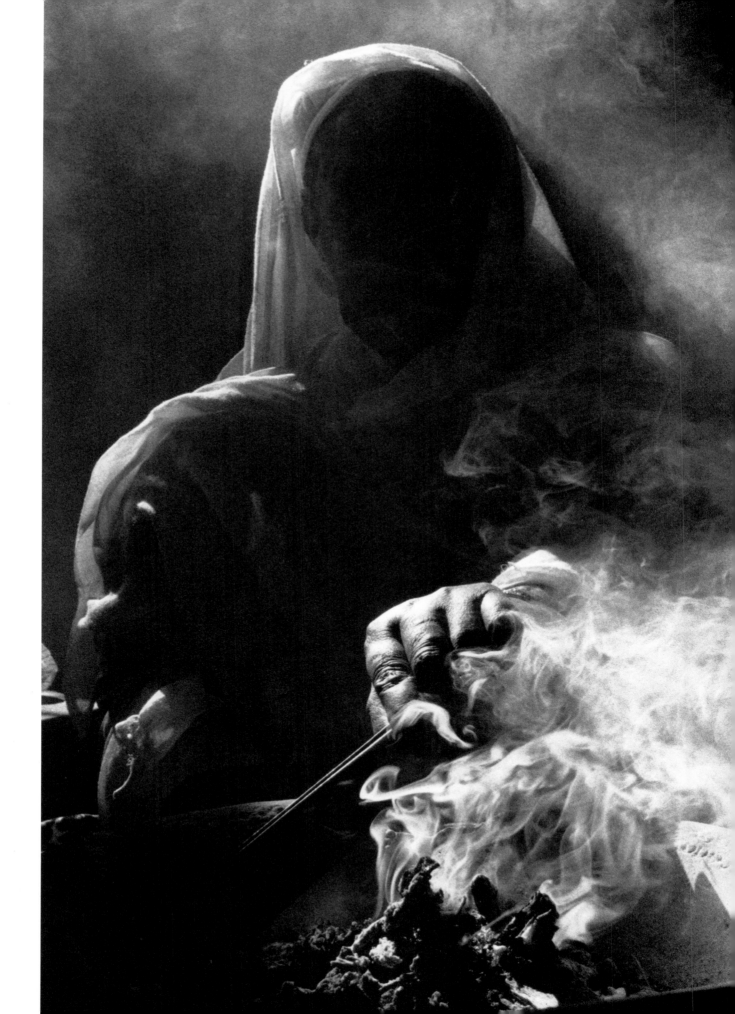

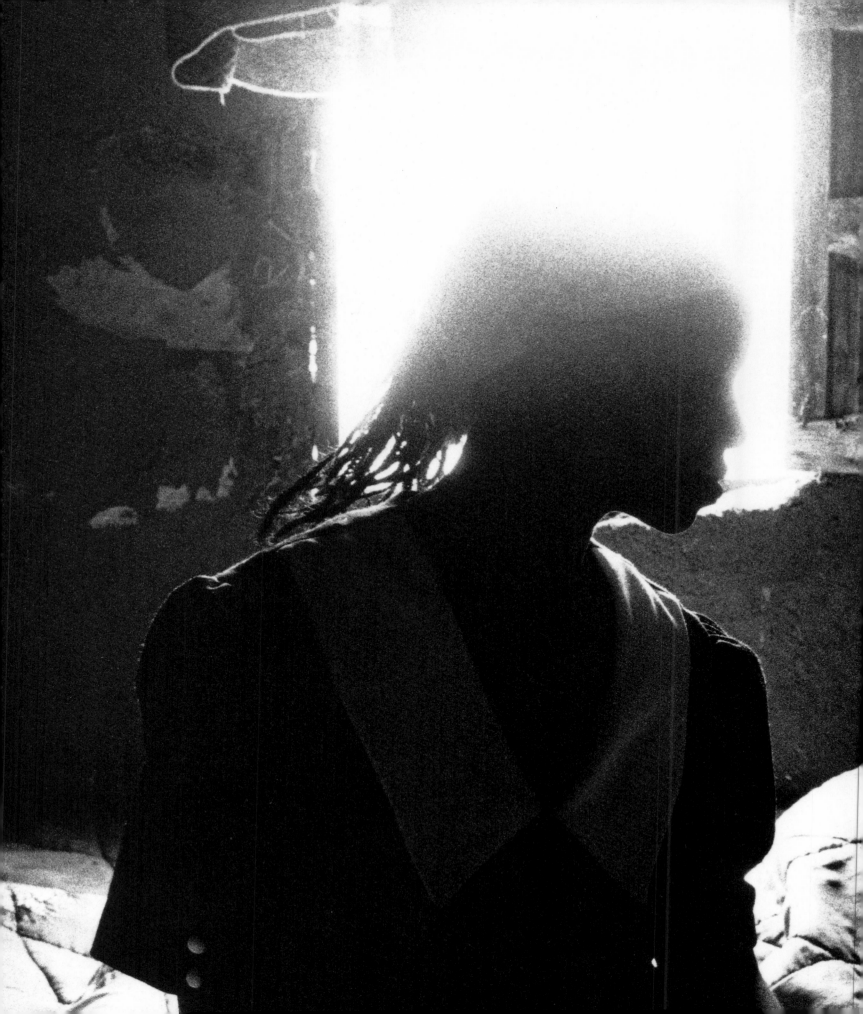

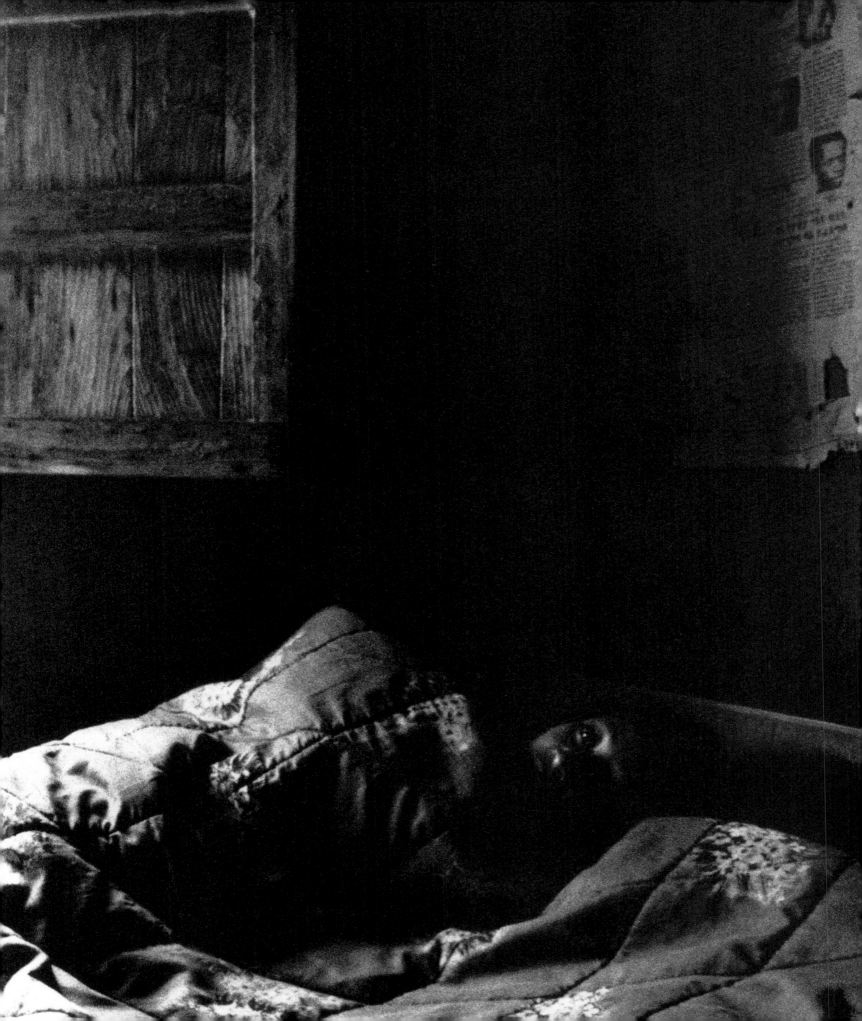

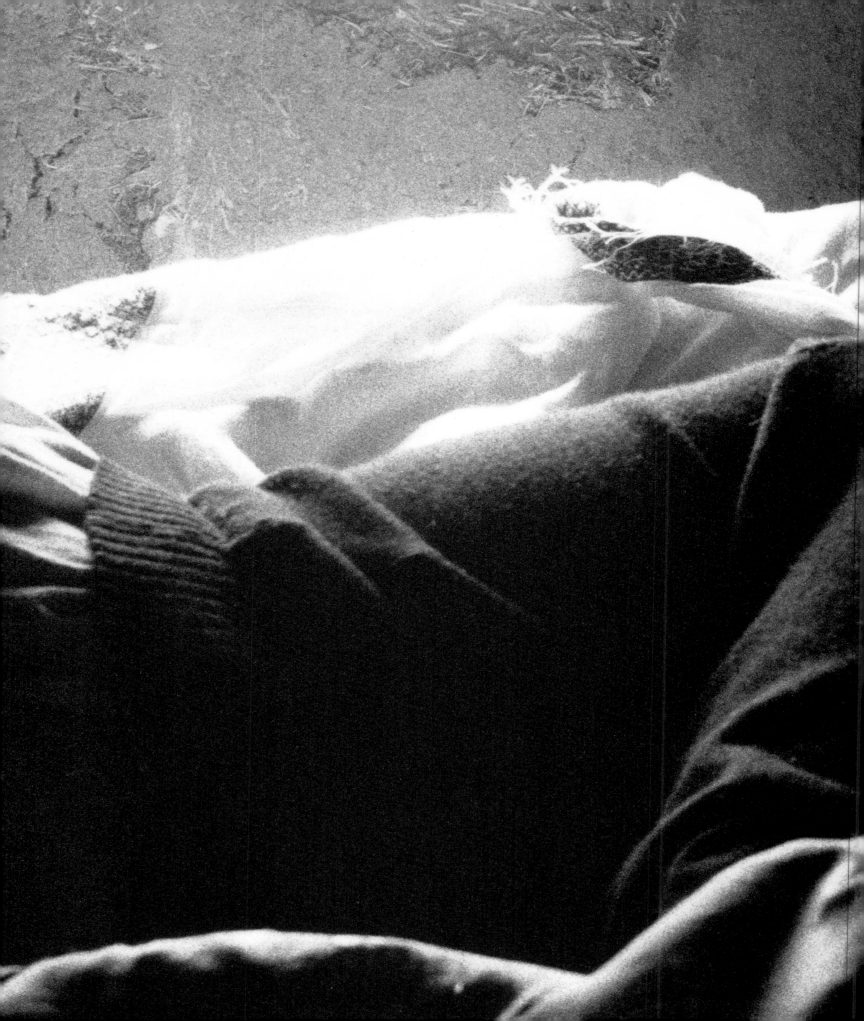

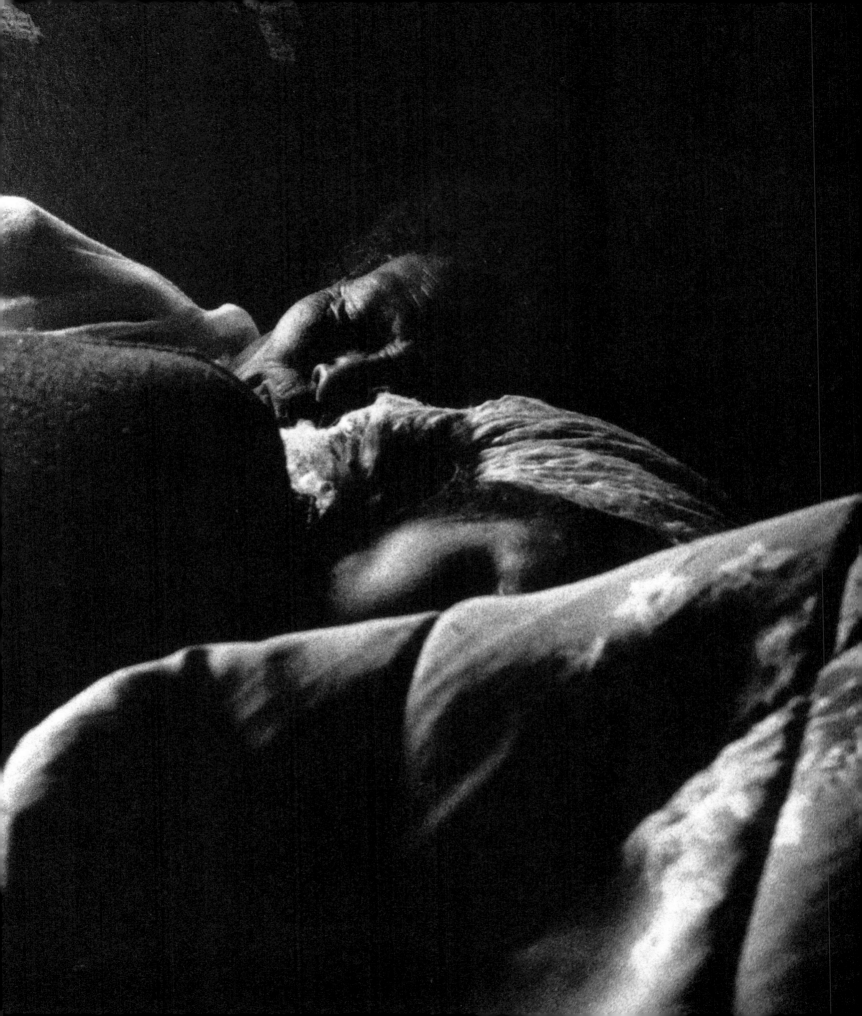

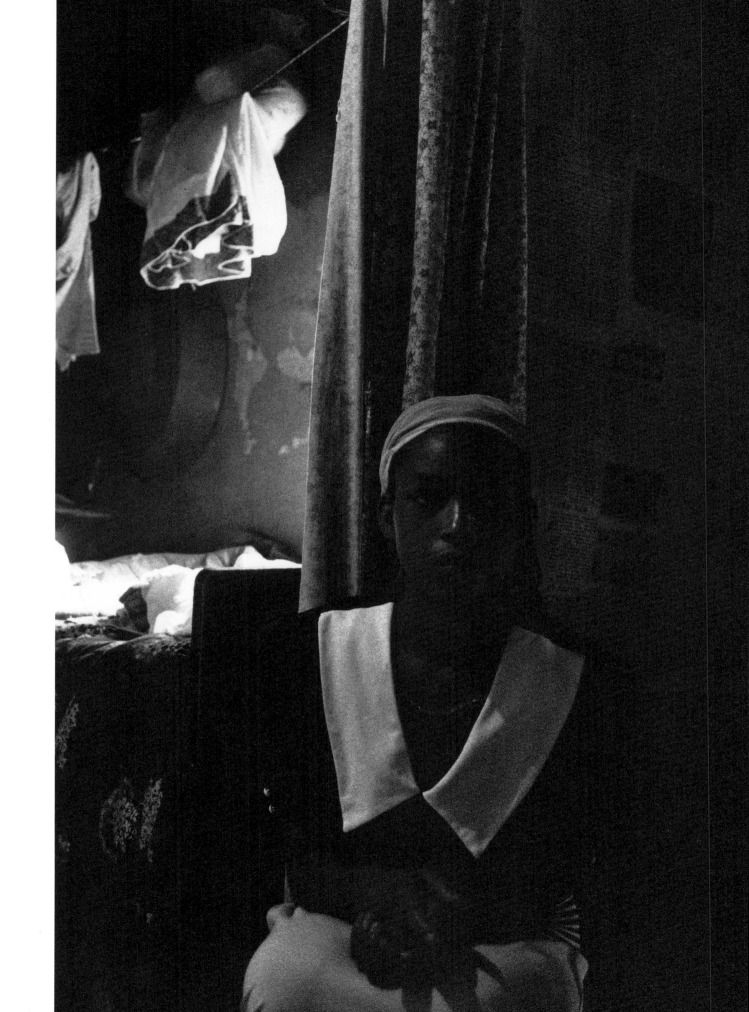

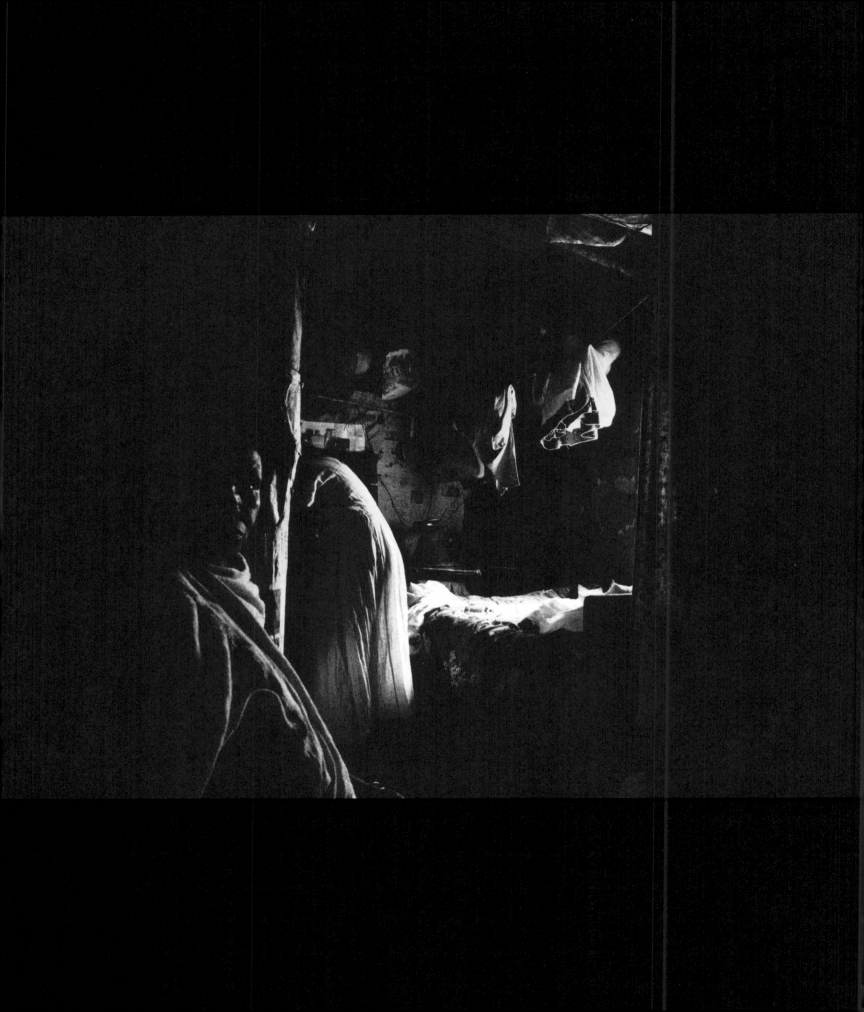

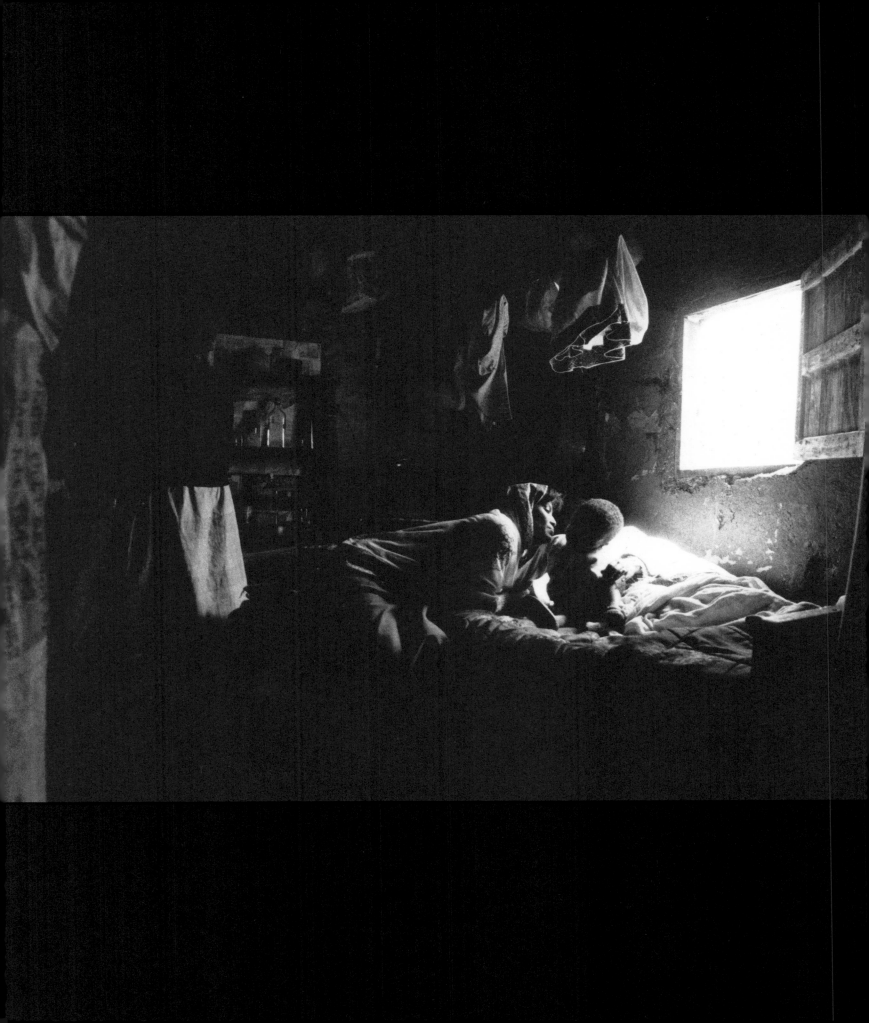

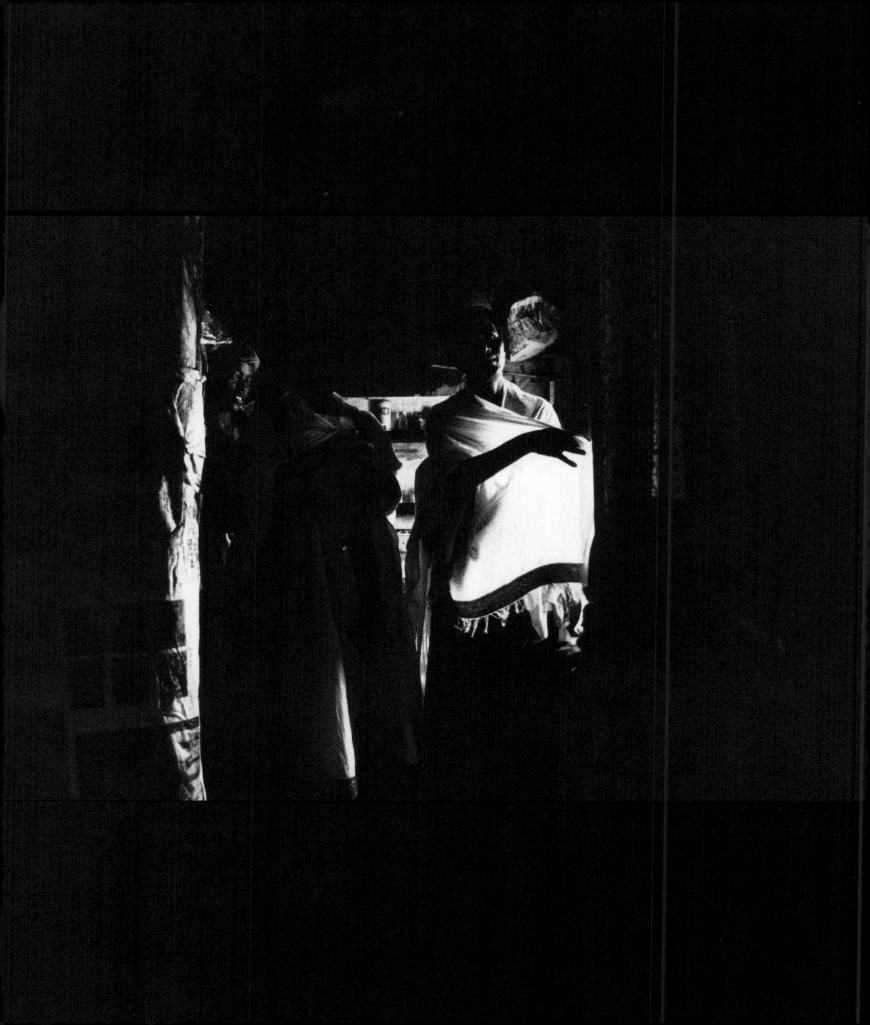

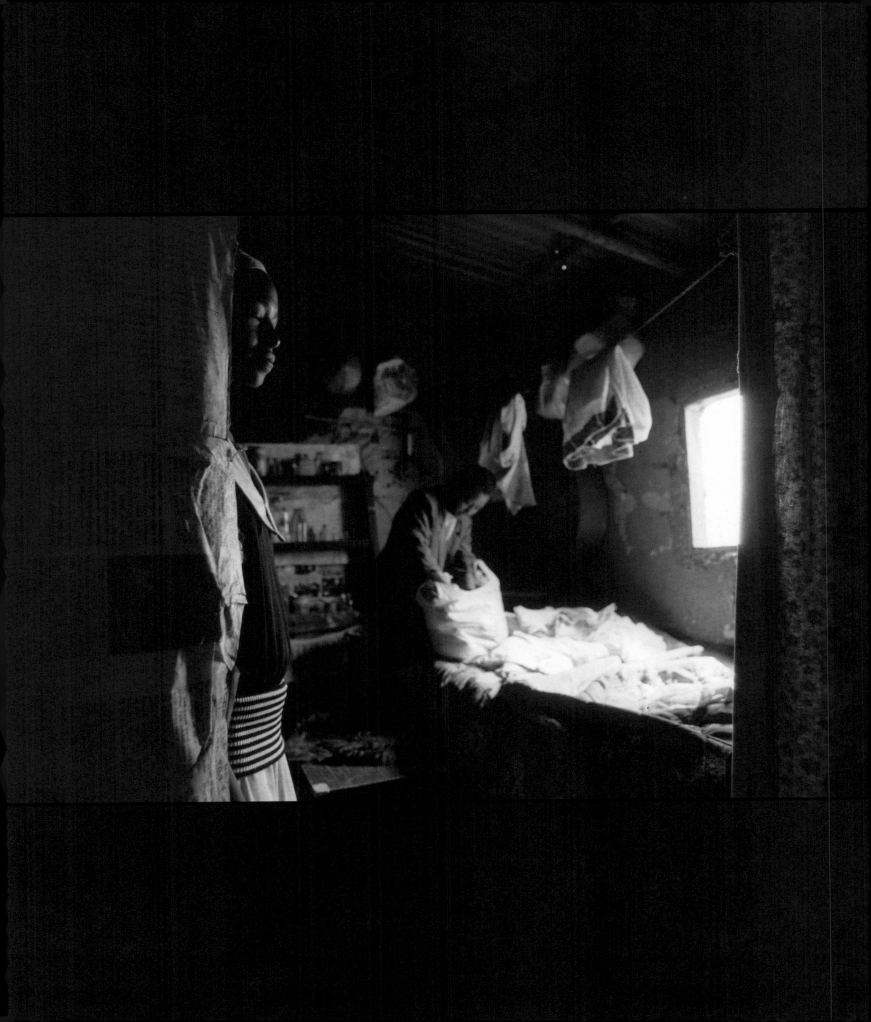

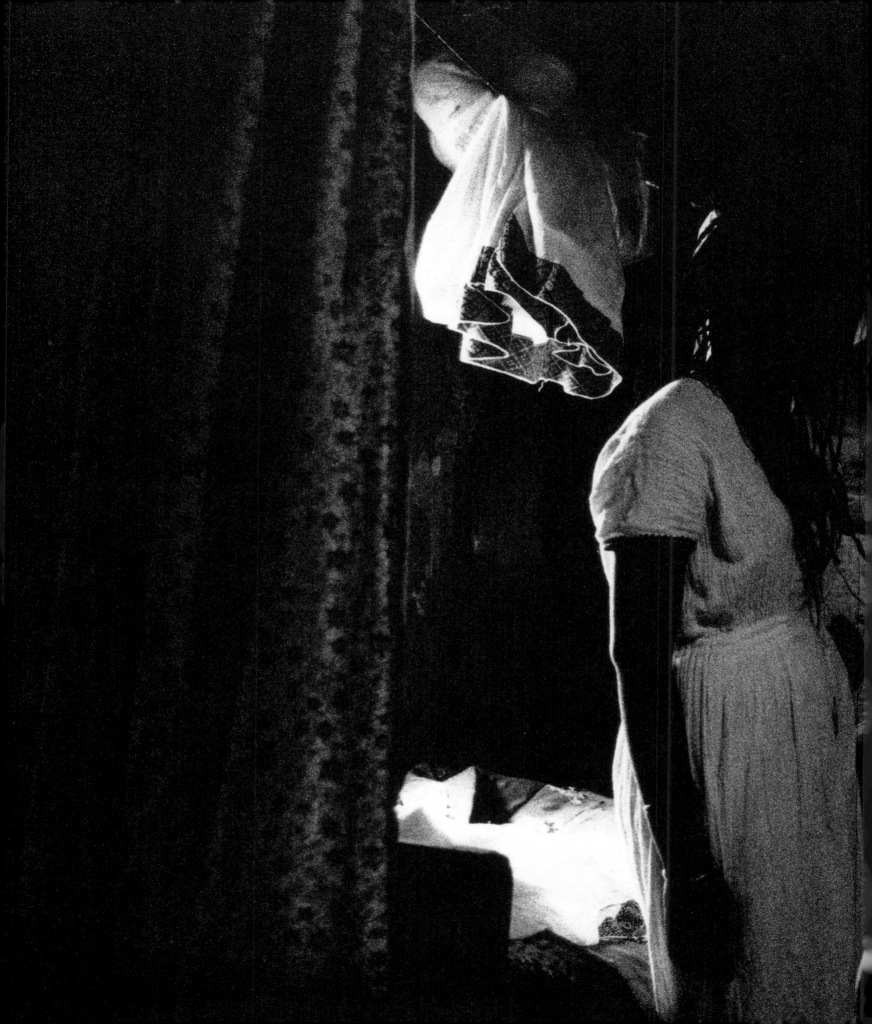

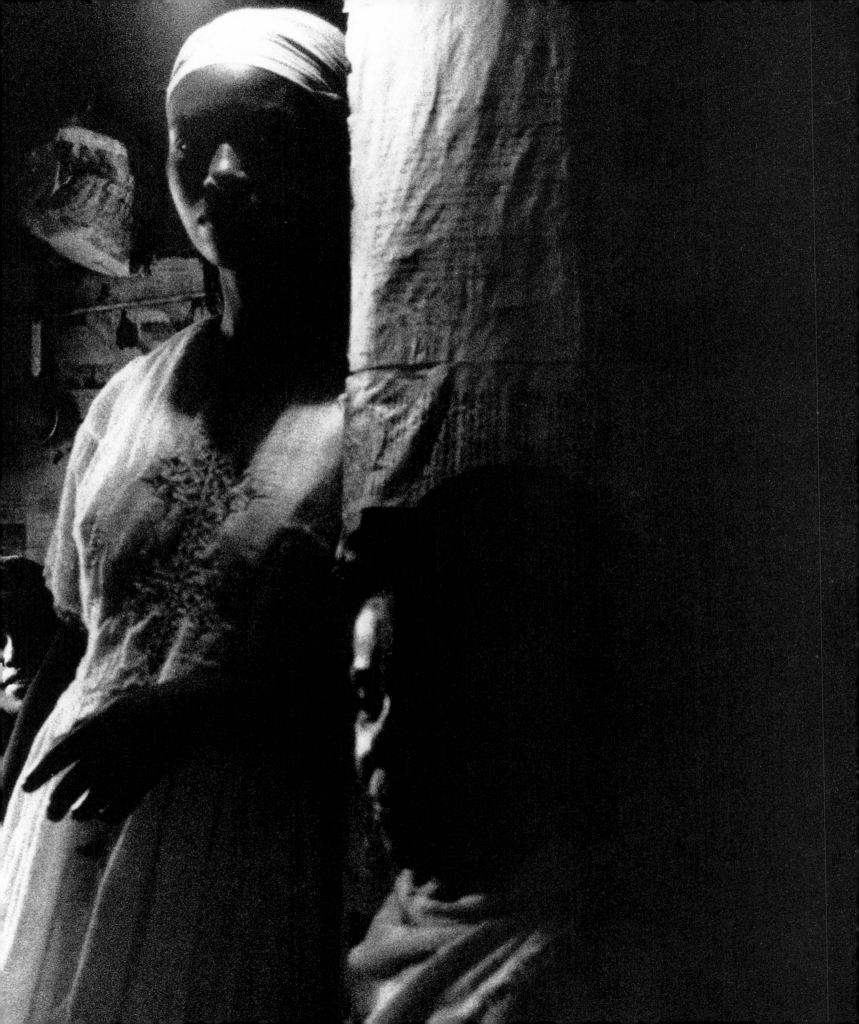

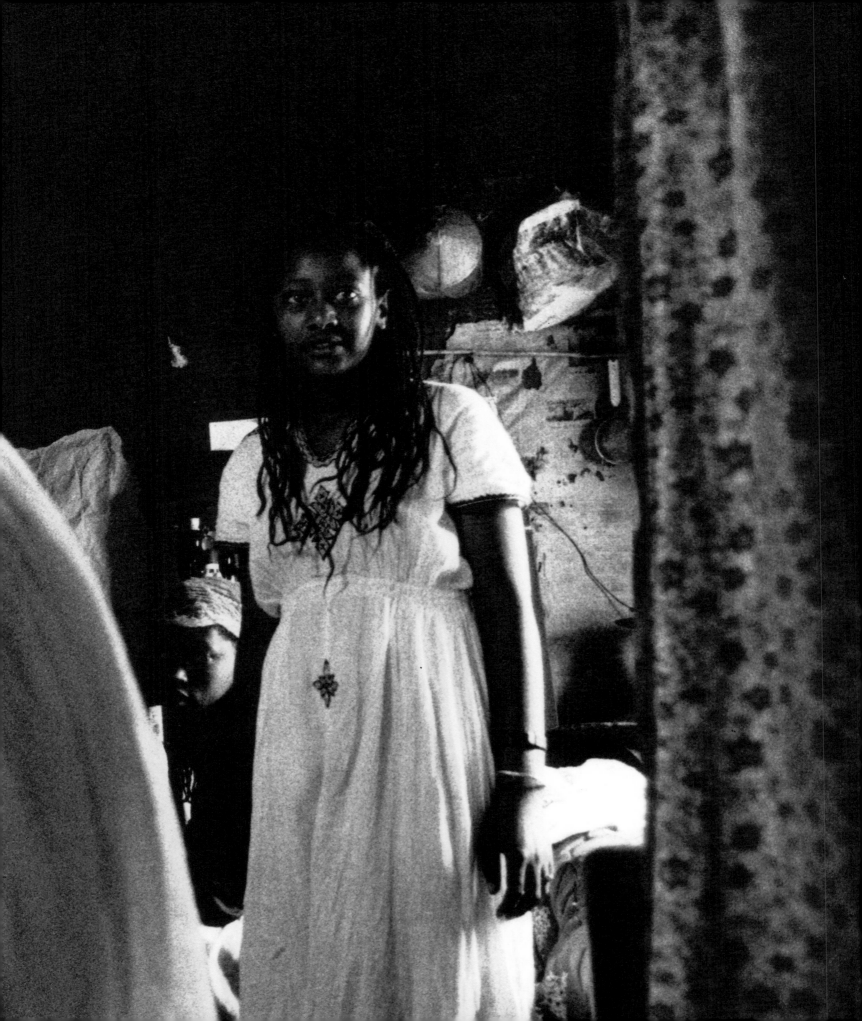

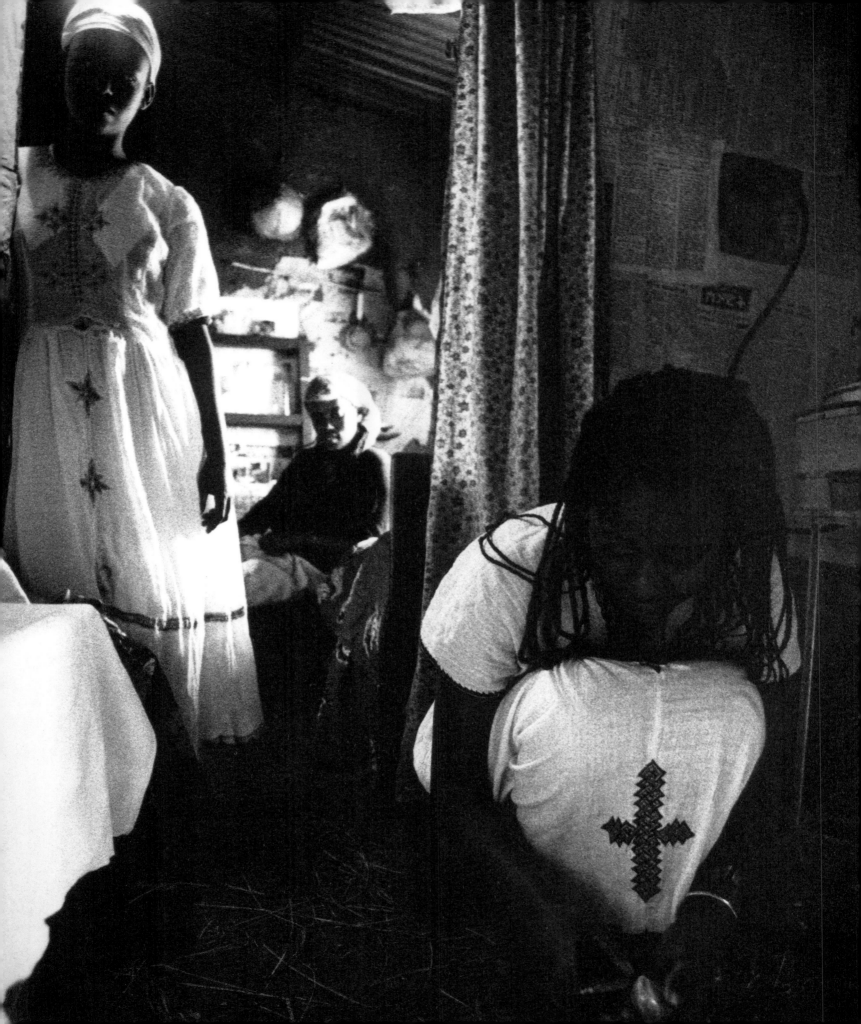

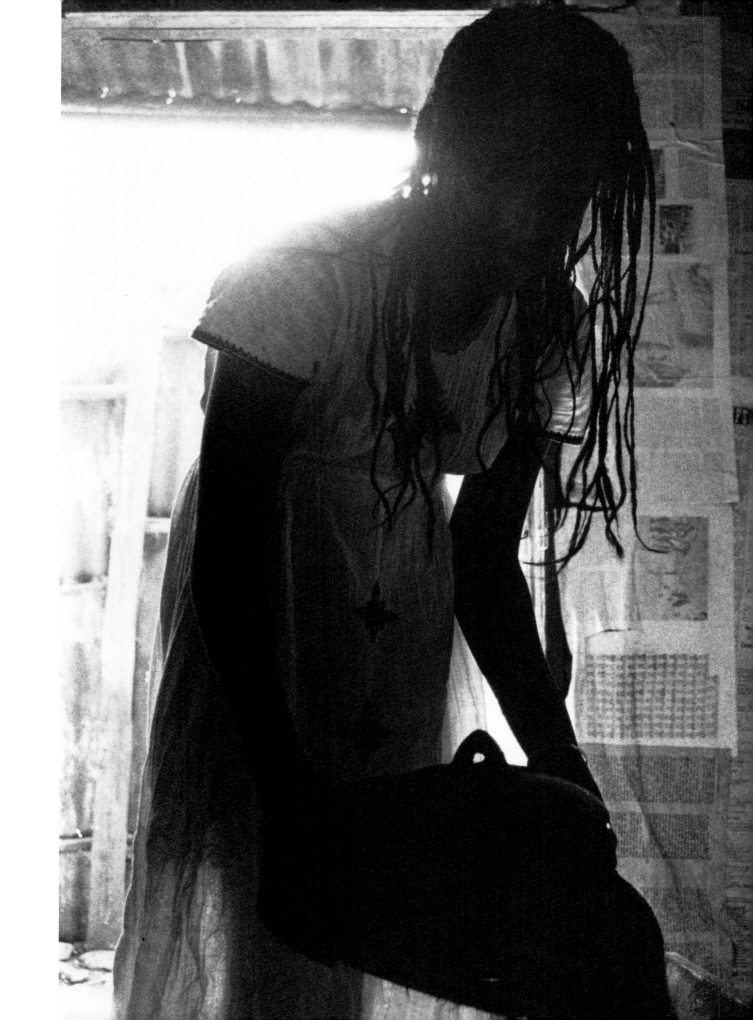

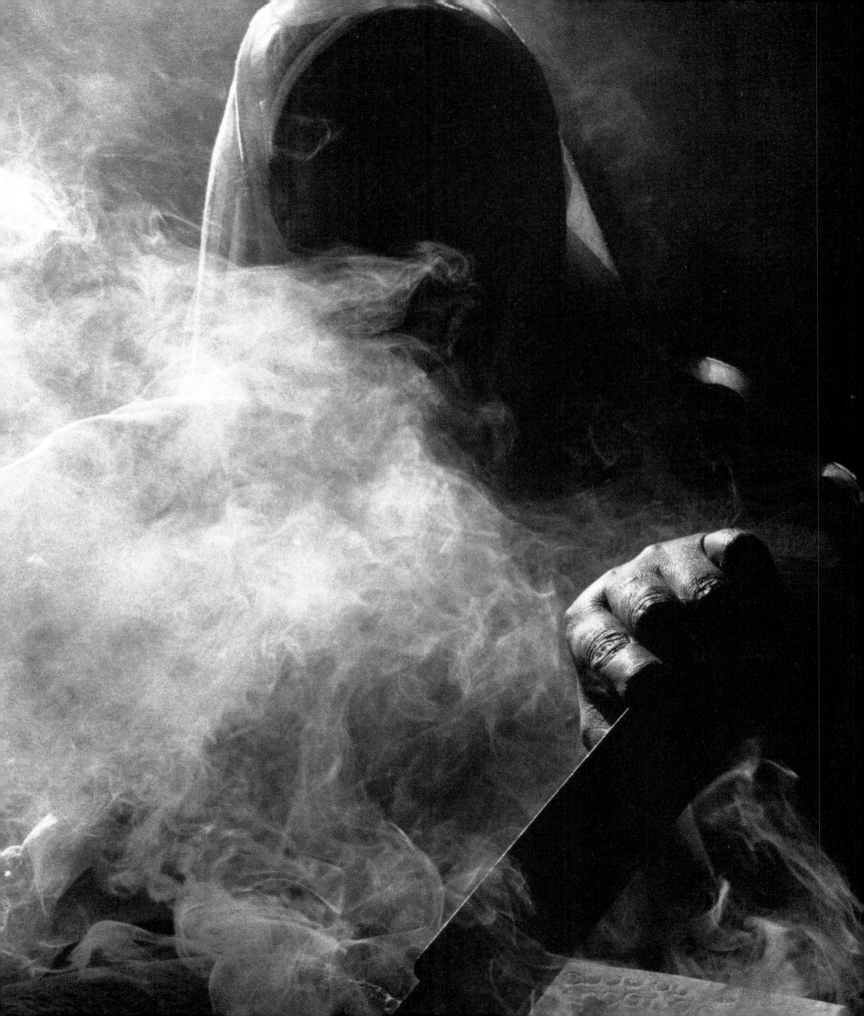

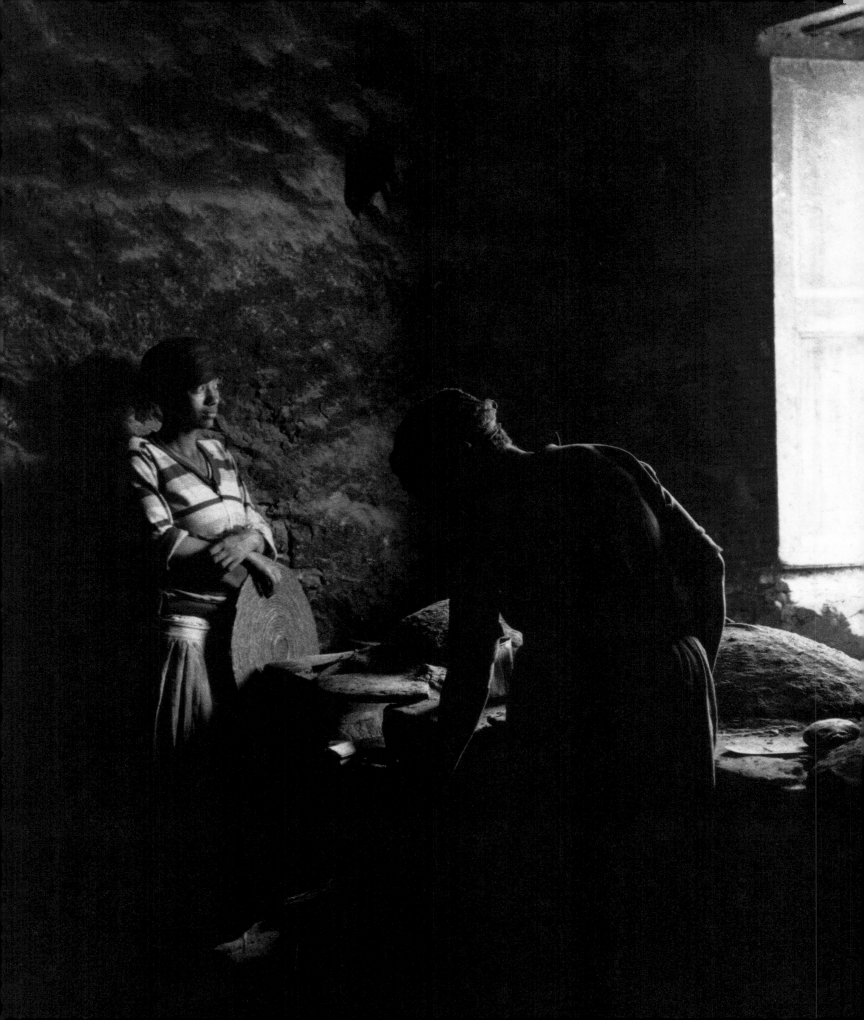

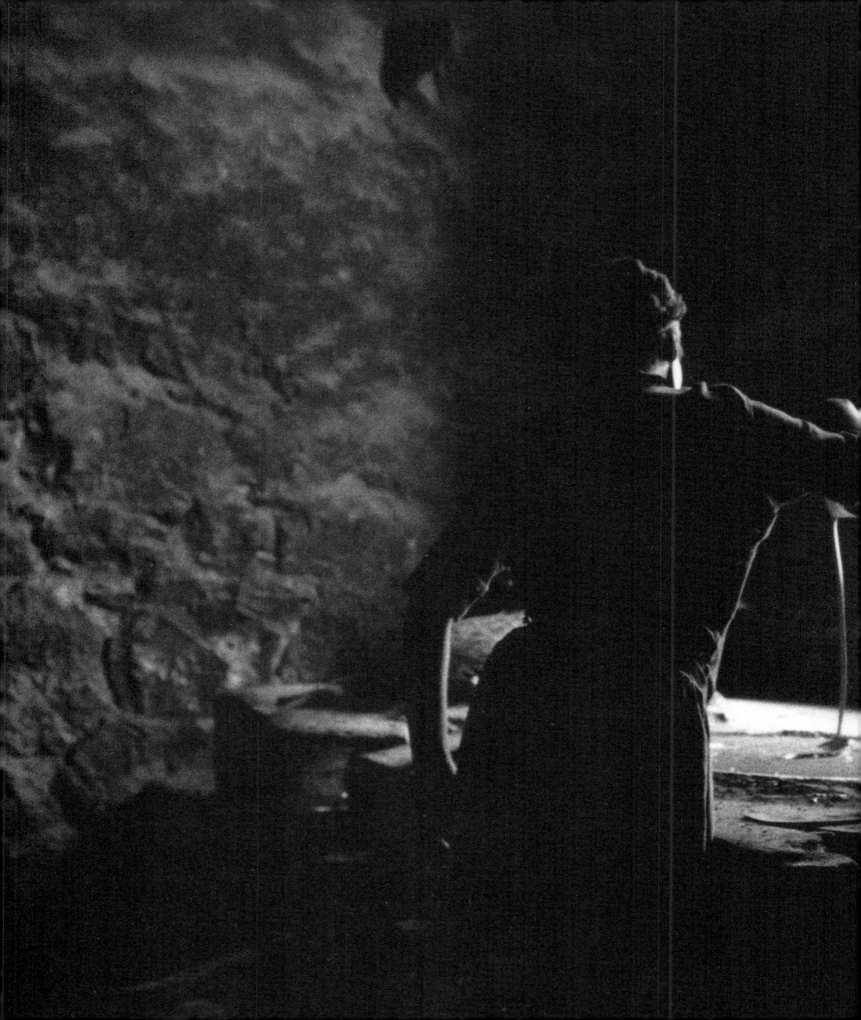

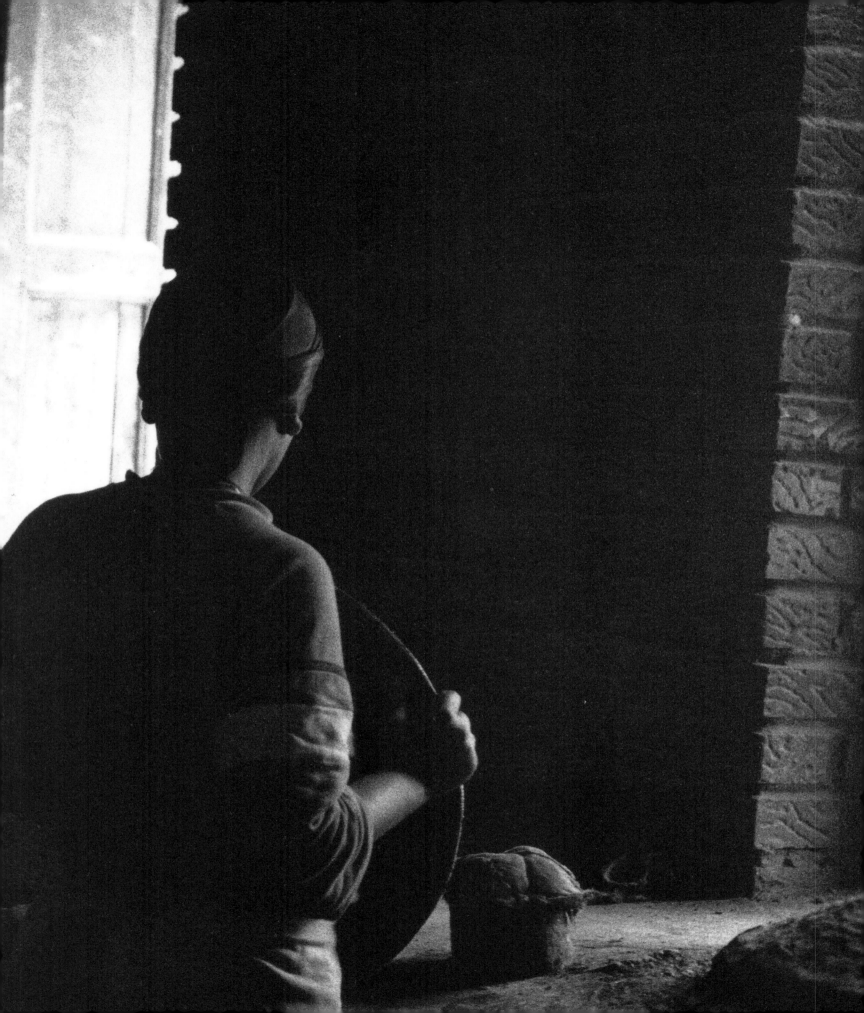

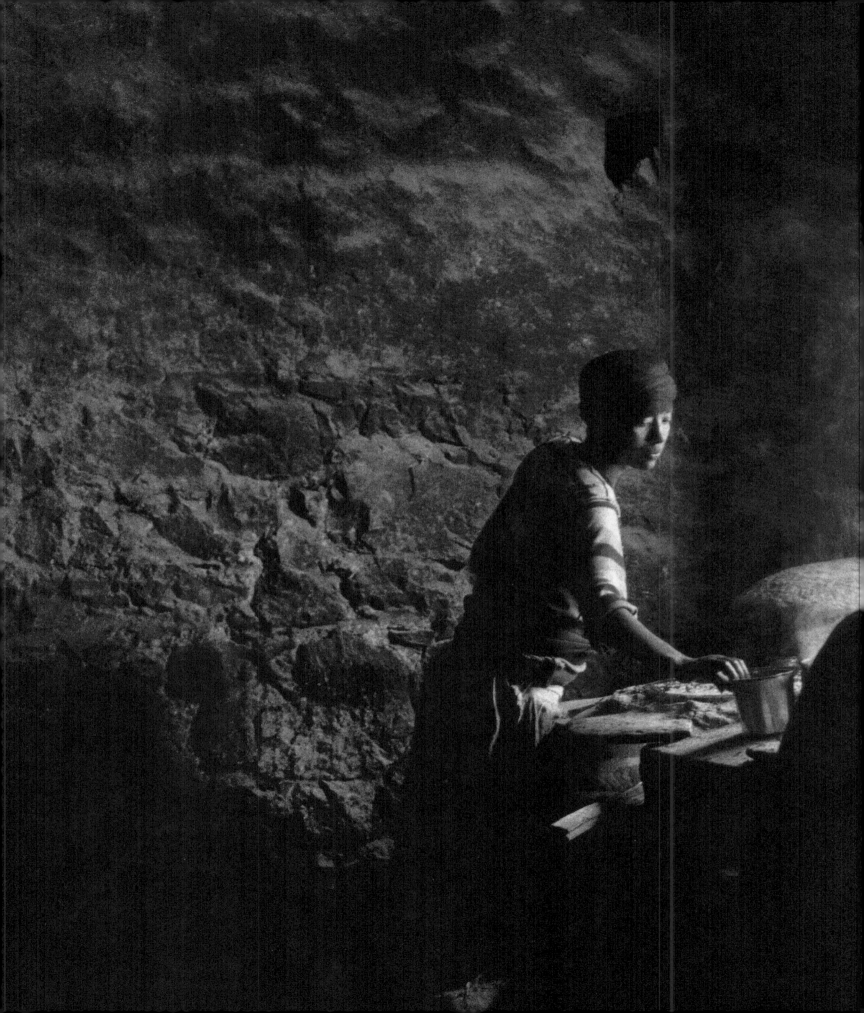

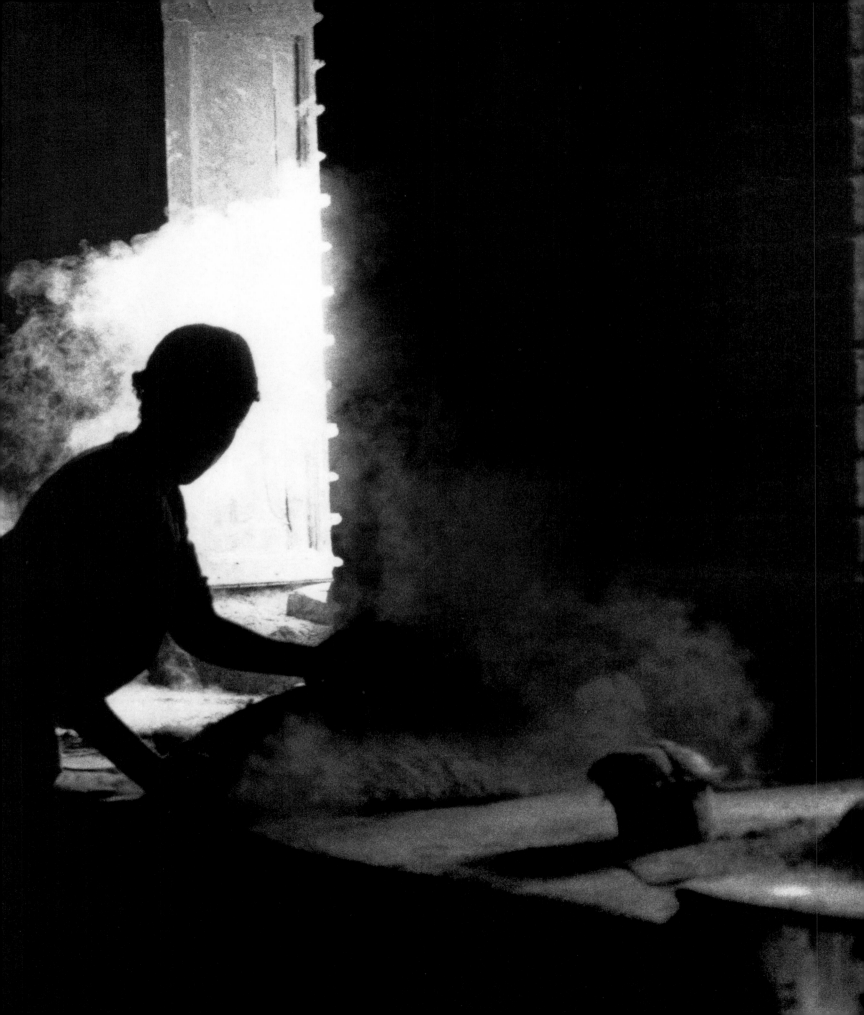

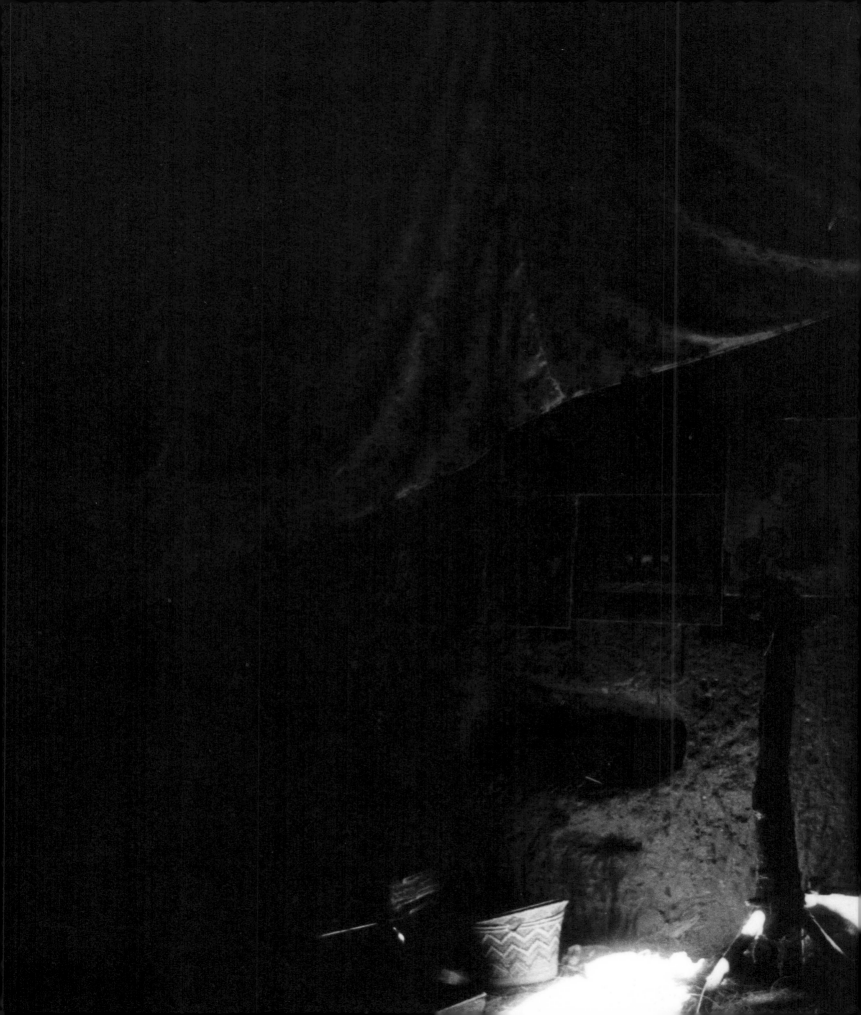

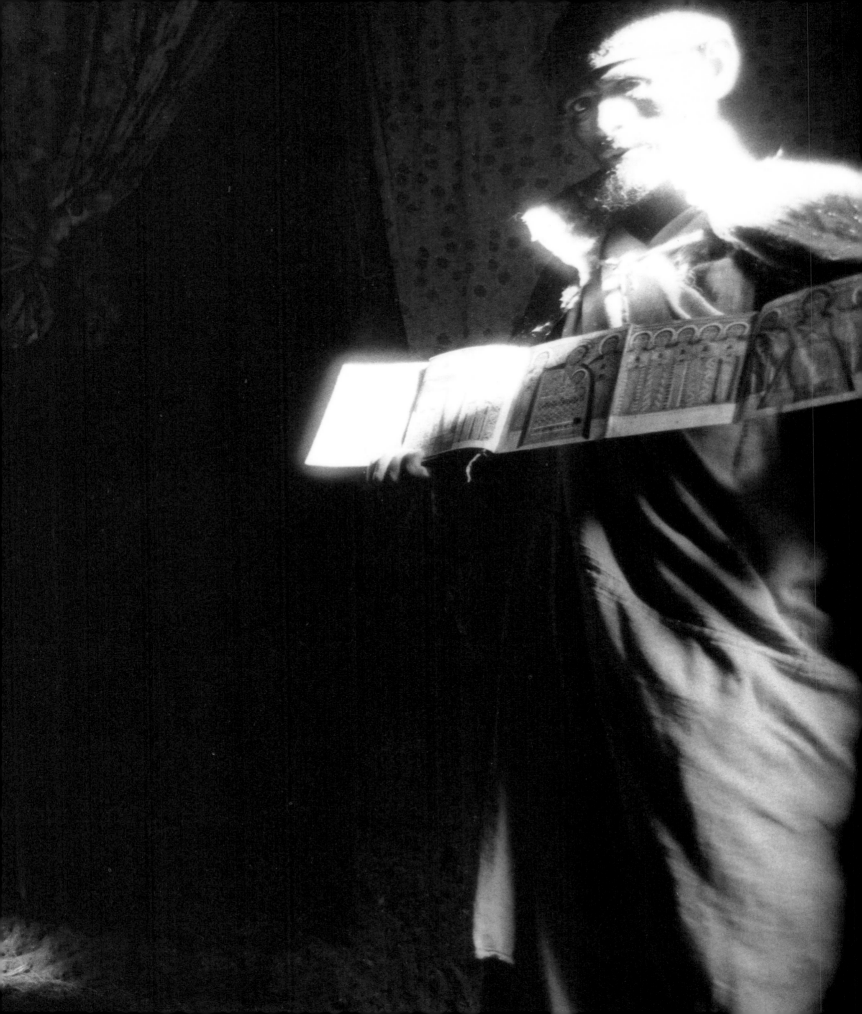

WALDE 4

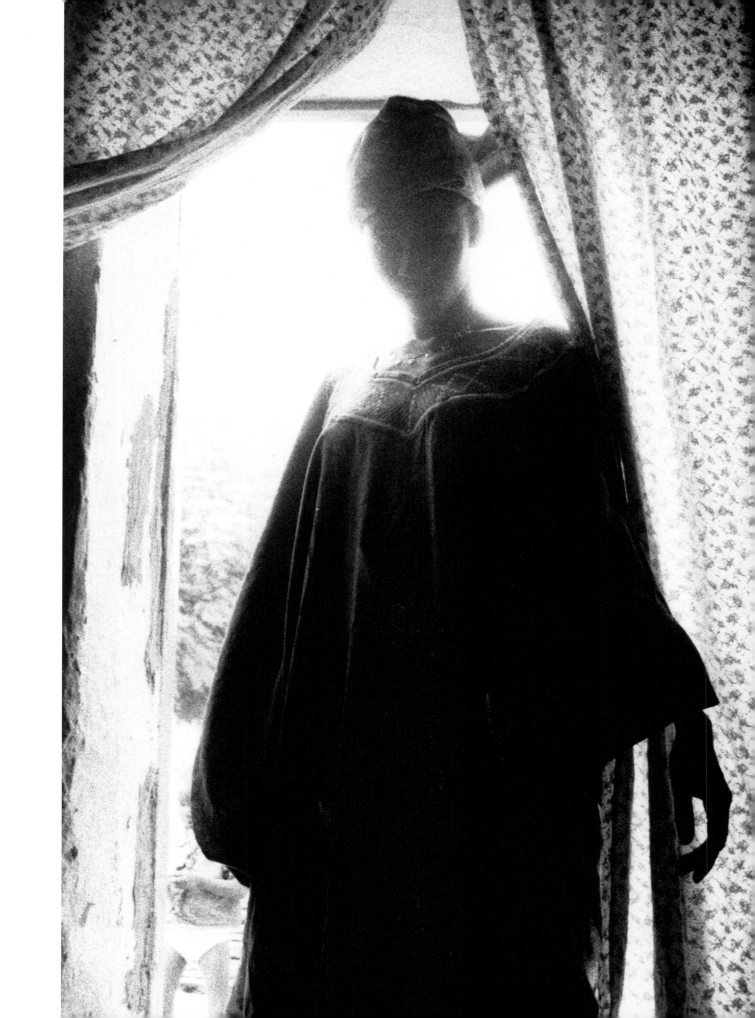

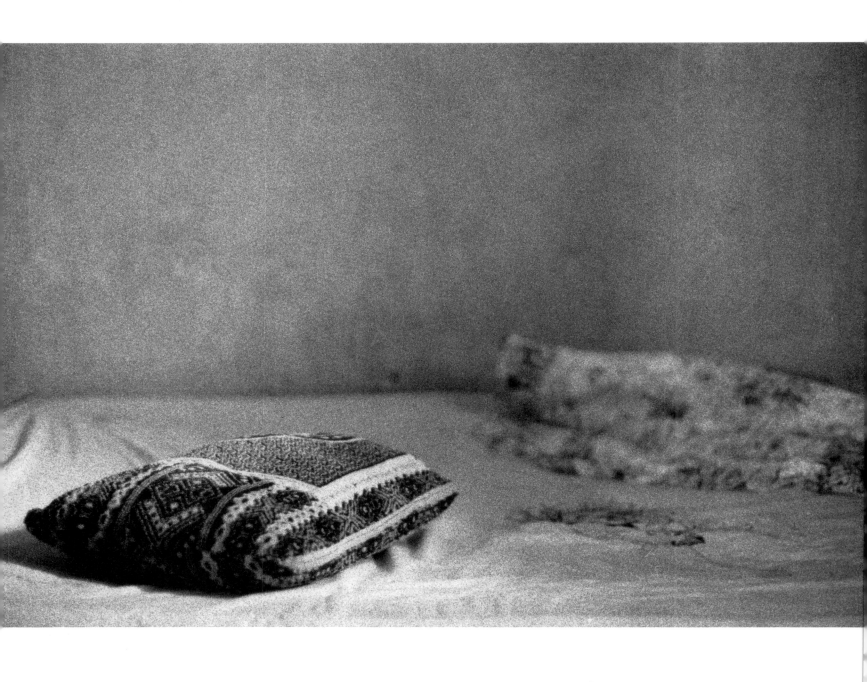

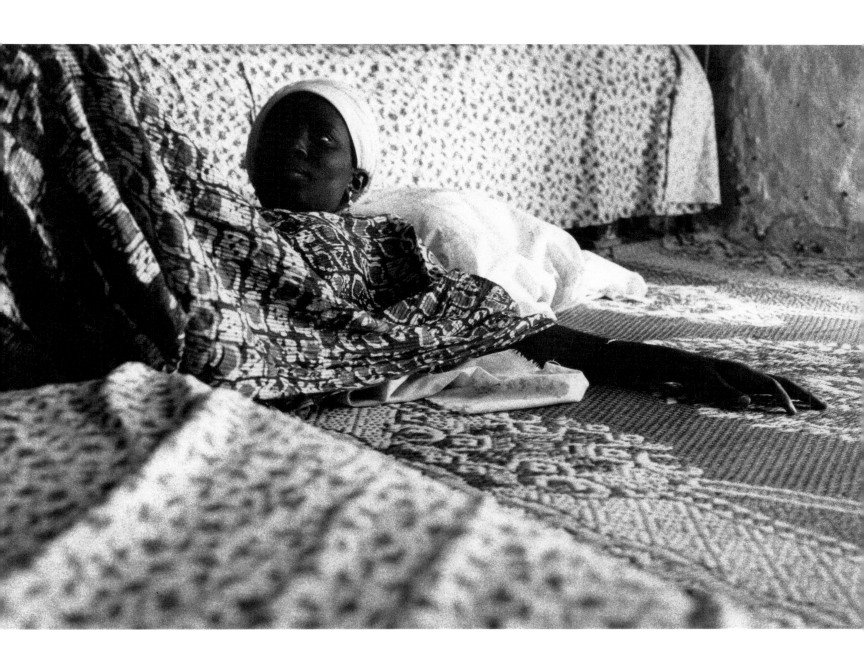

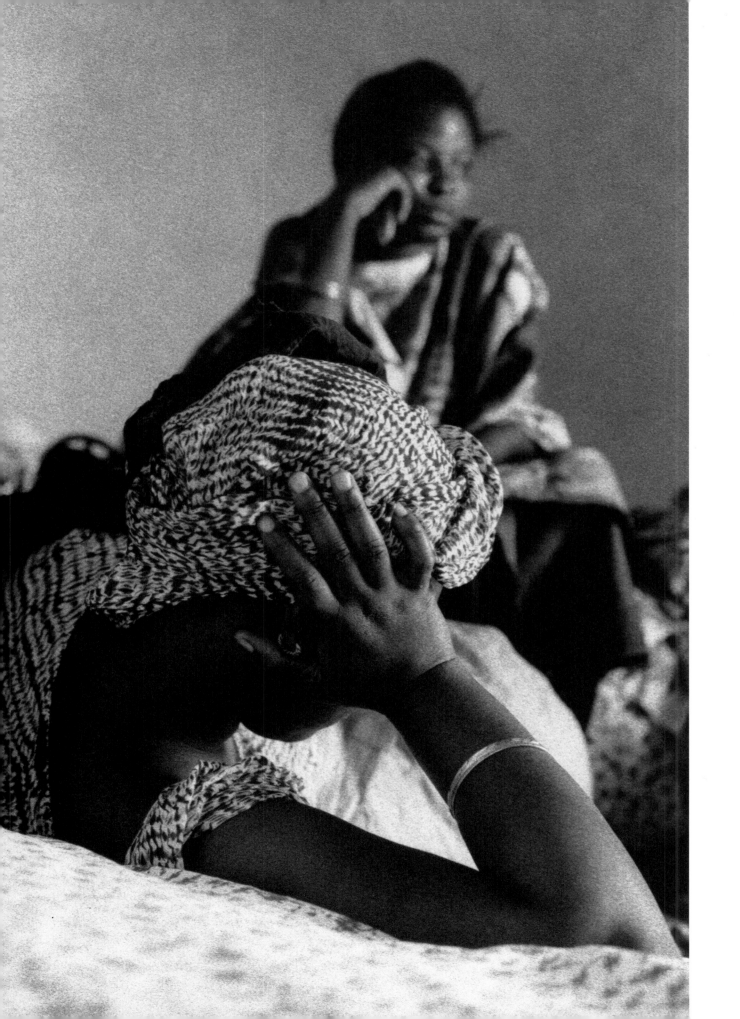

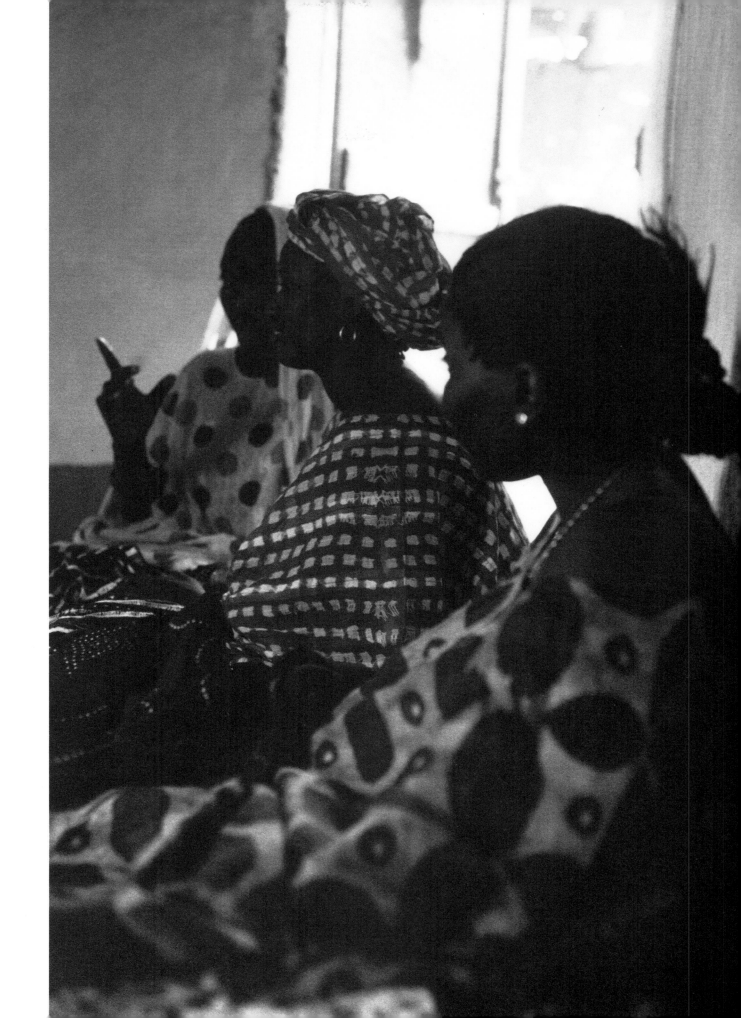

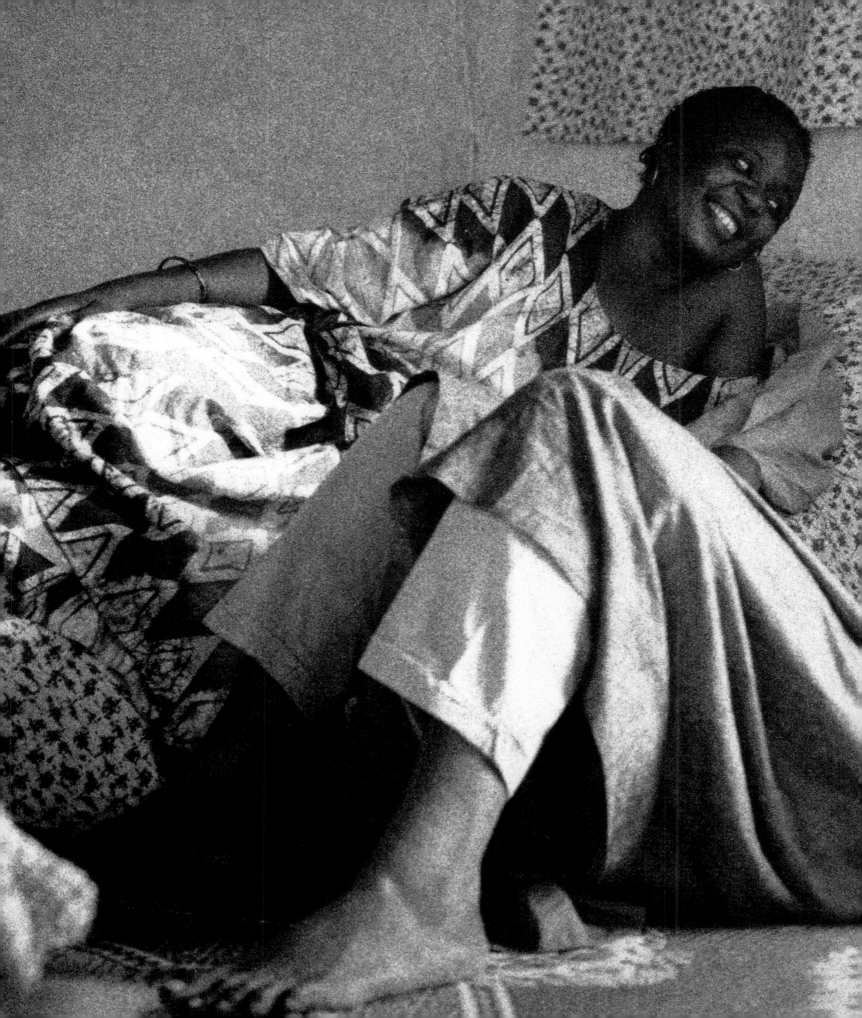

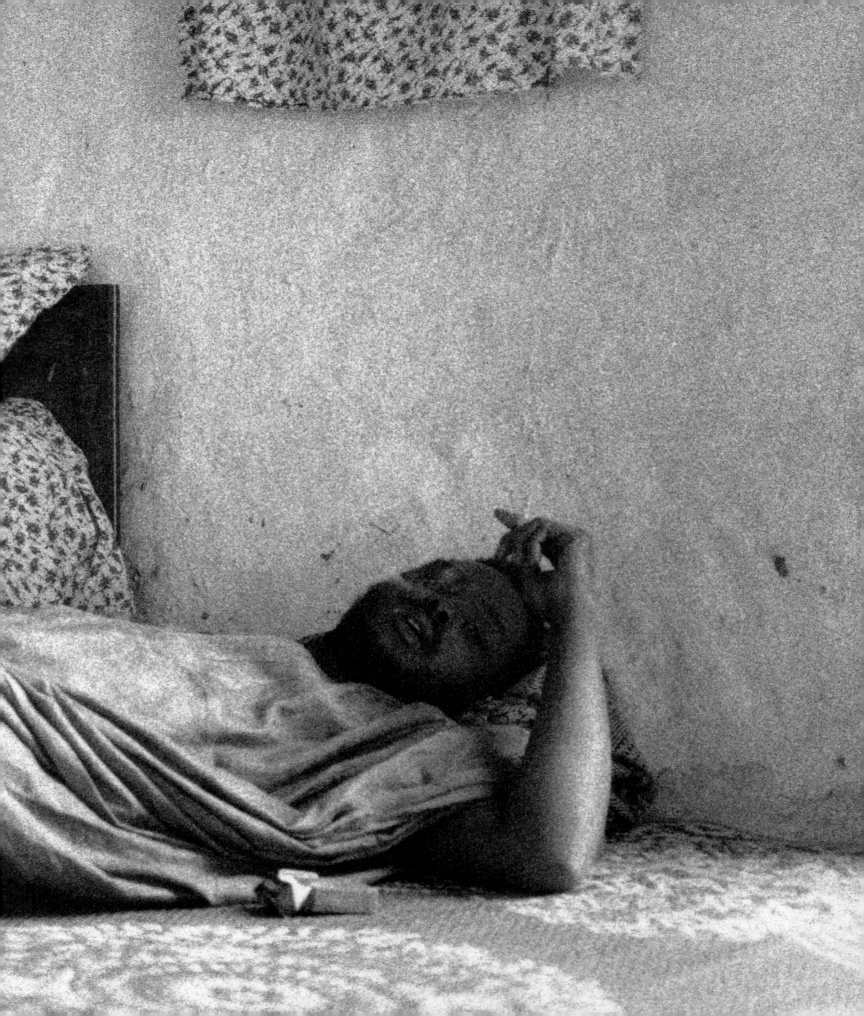

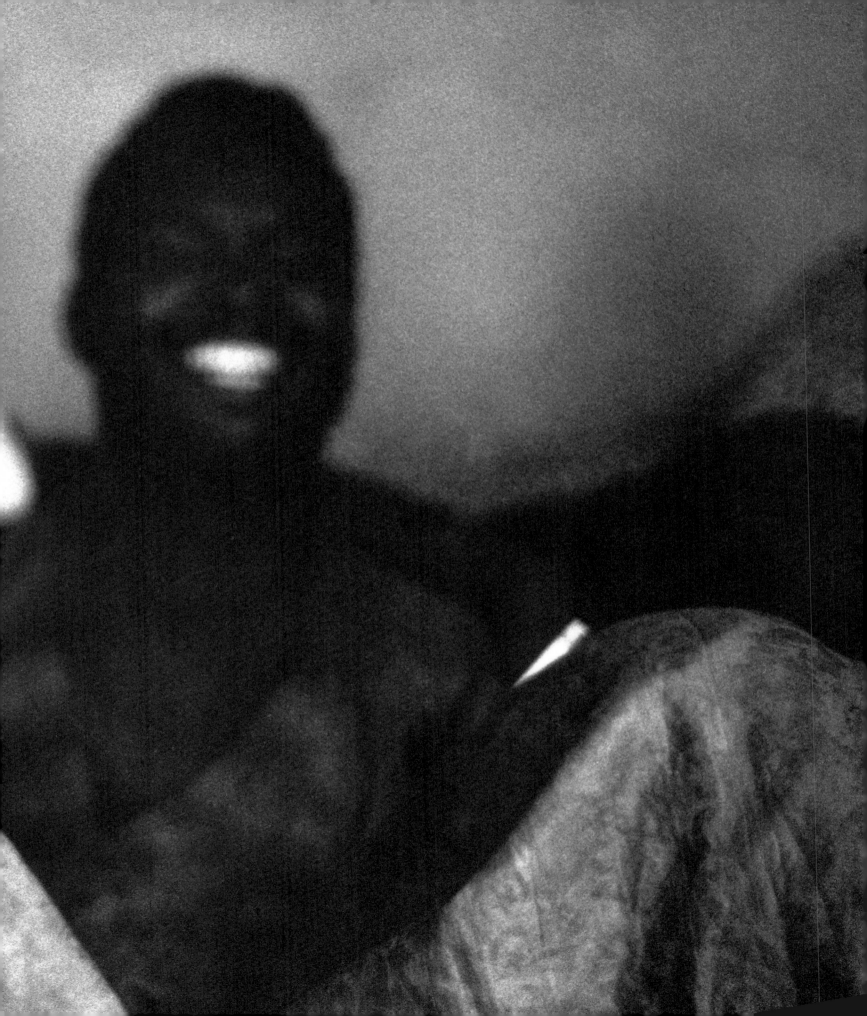

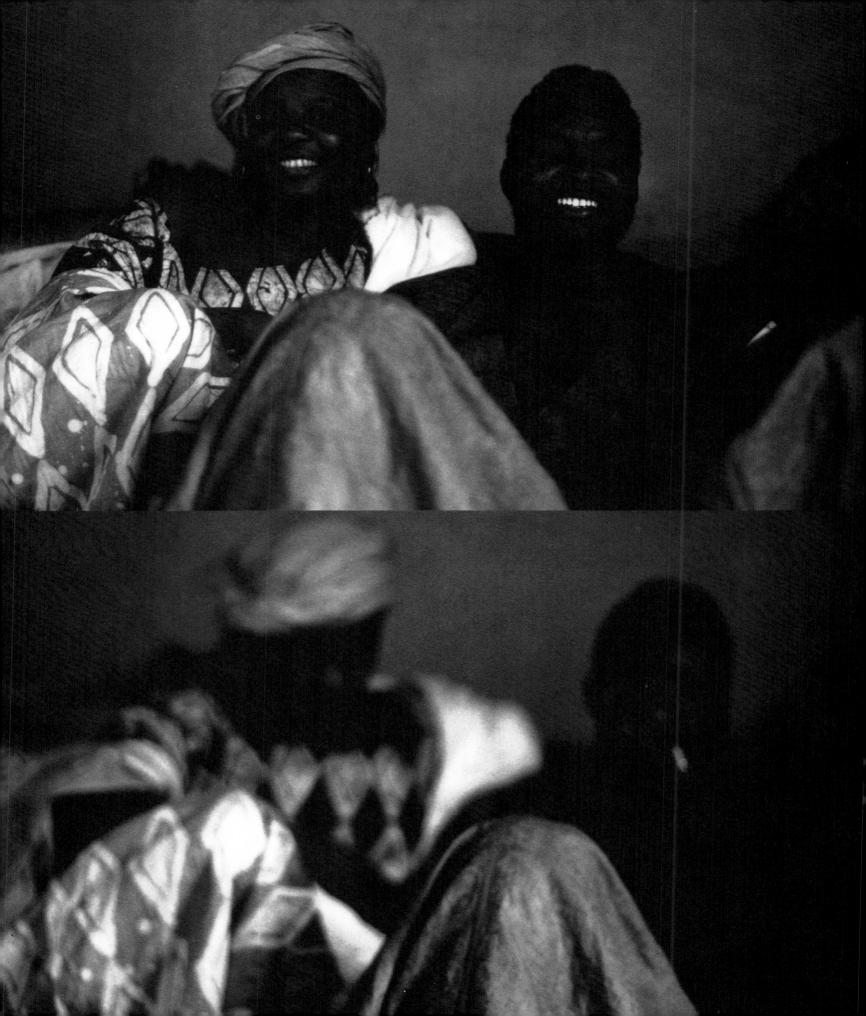

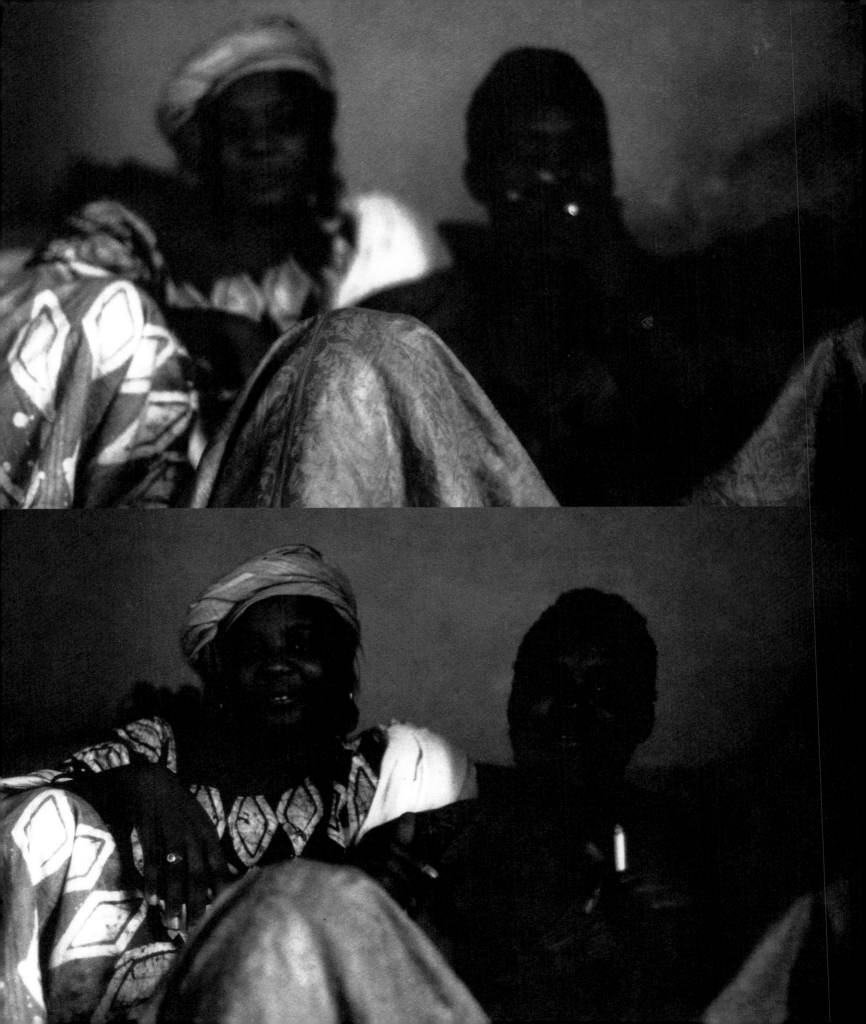

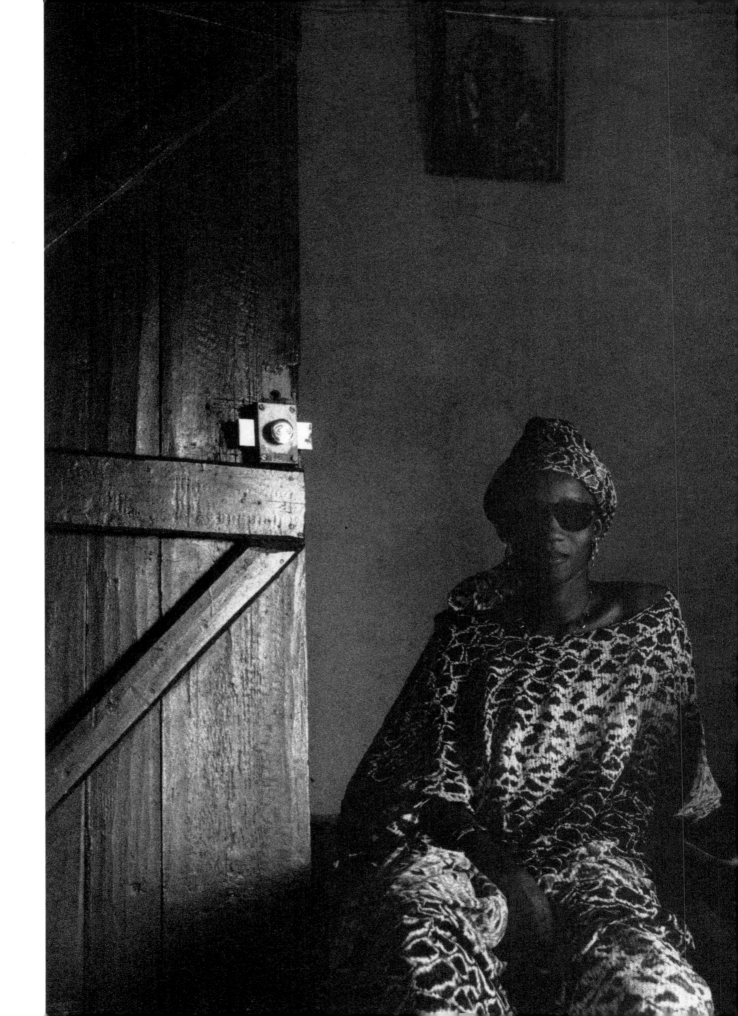

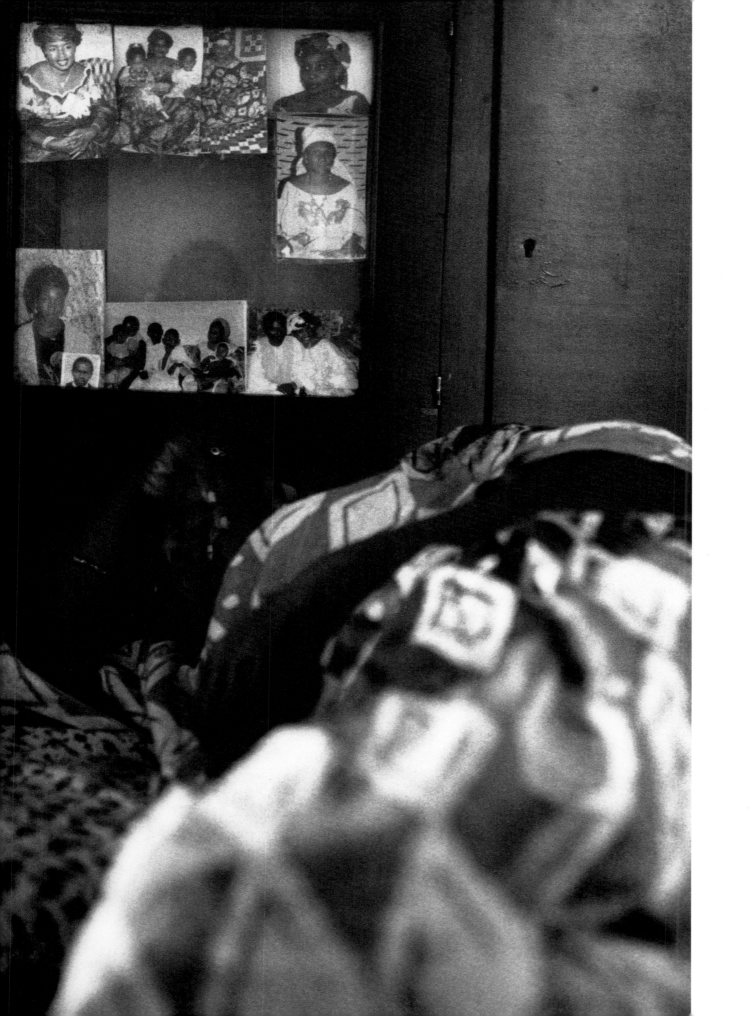

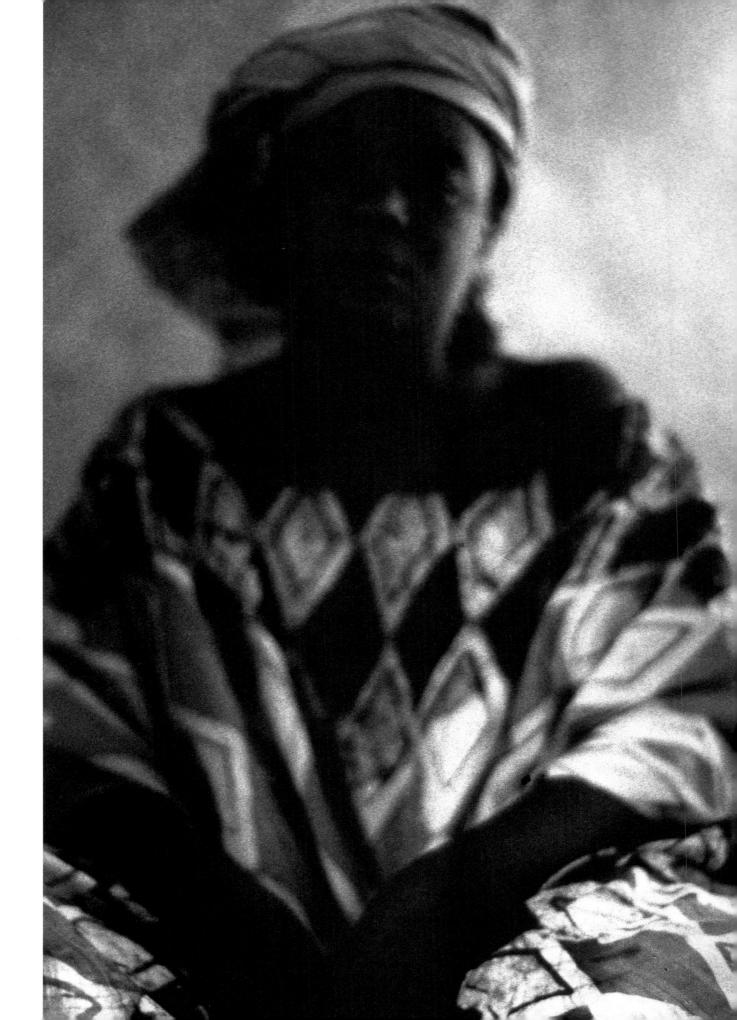

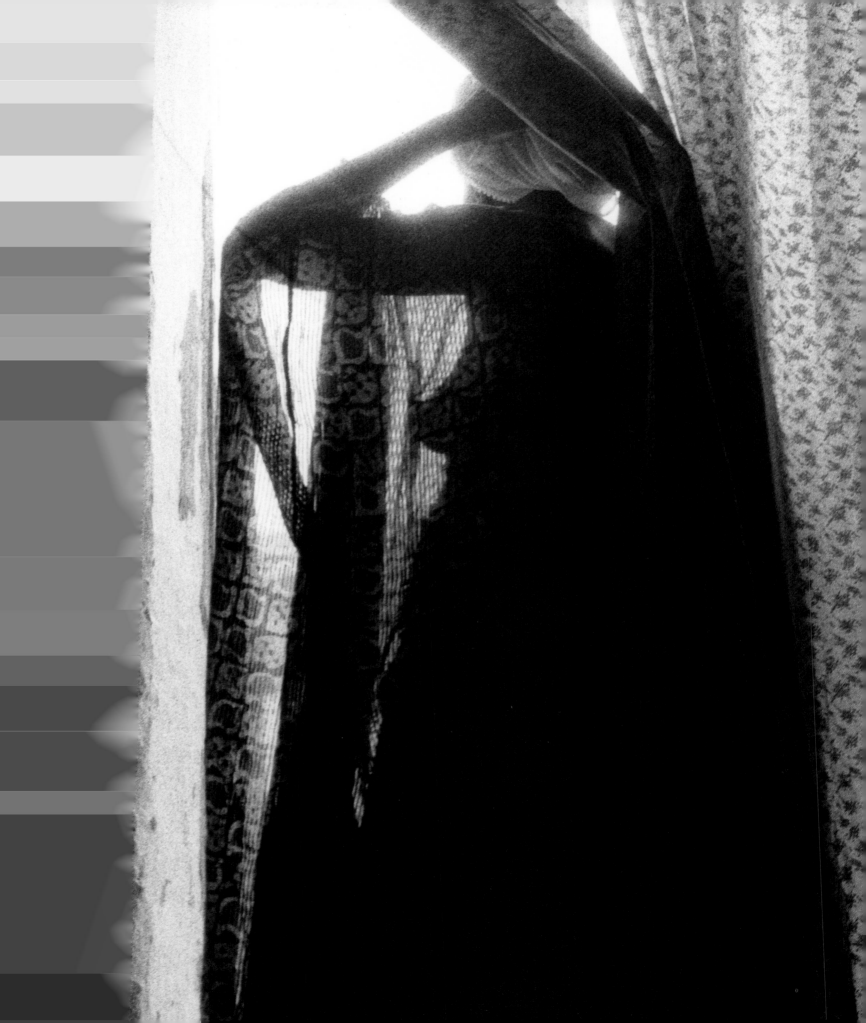

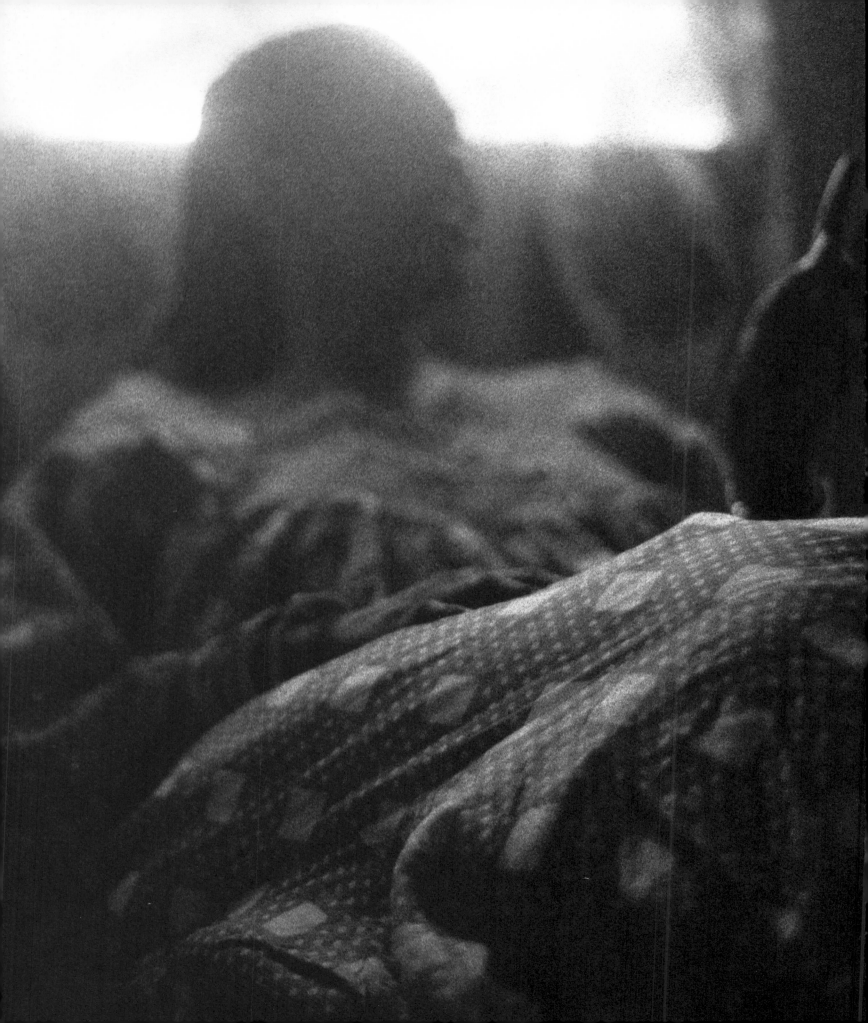

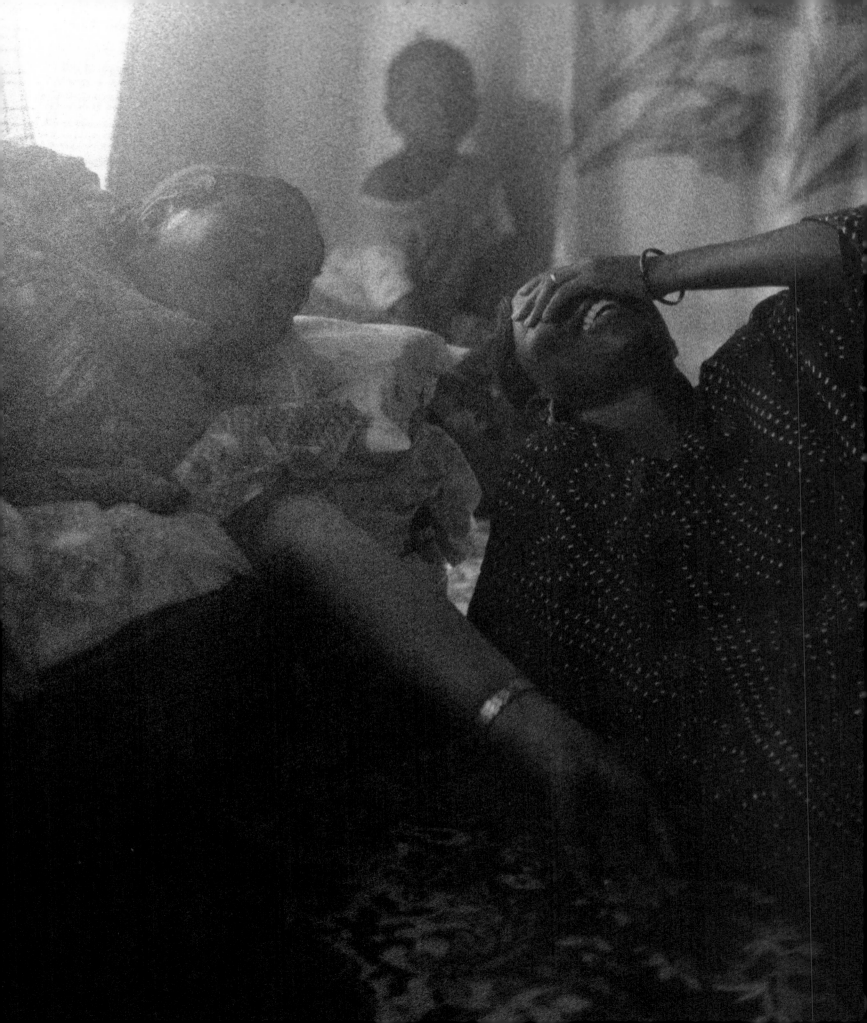

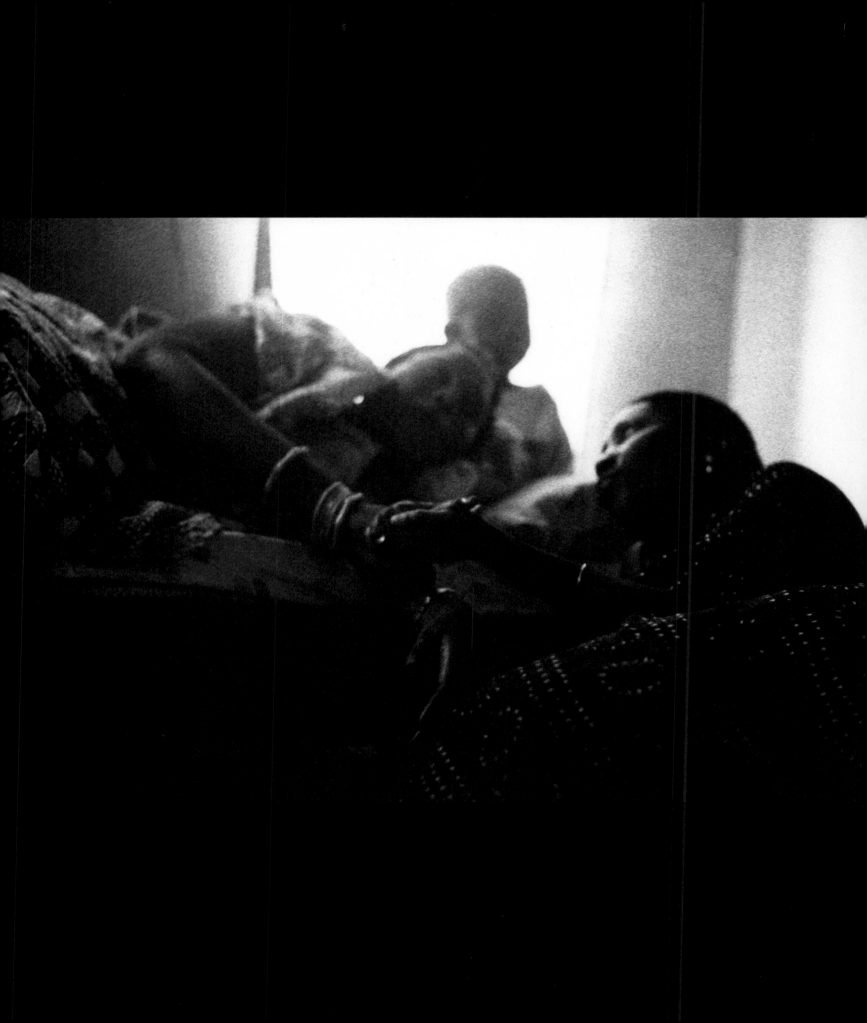

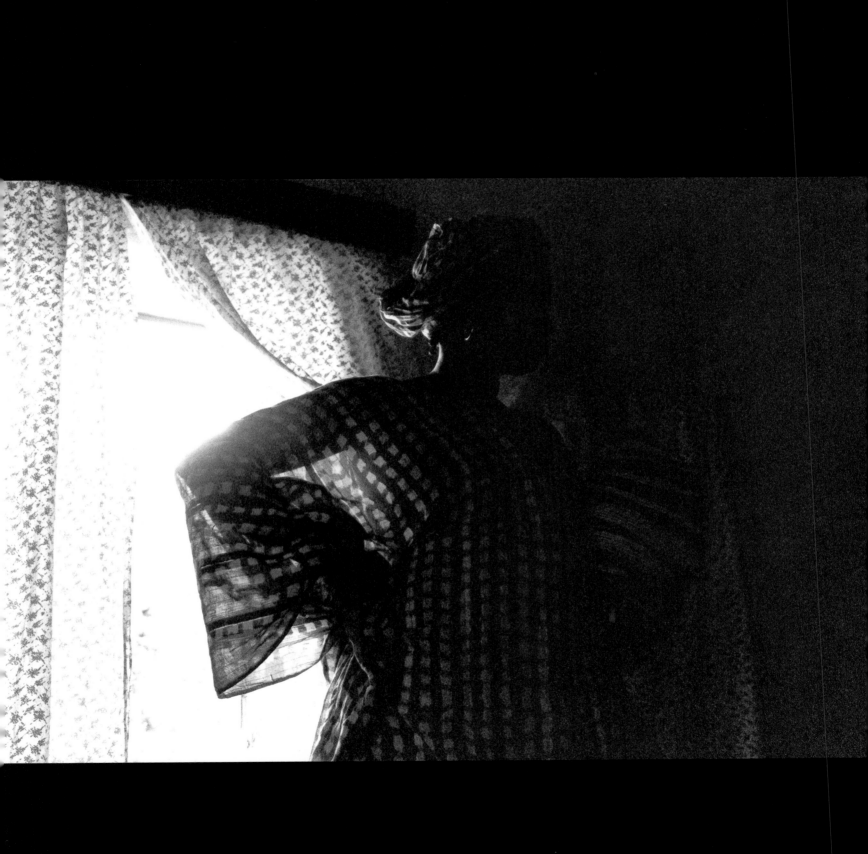

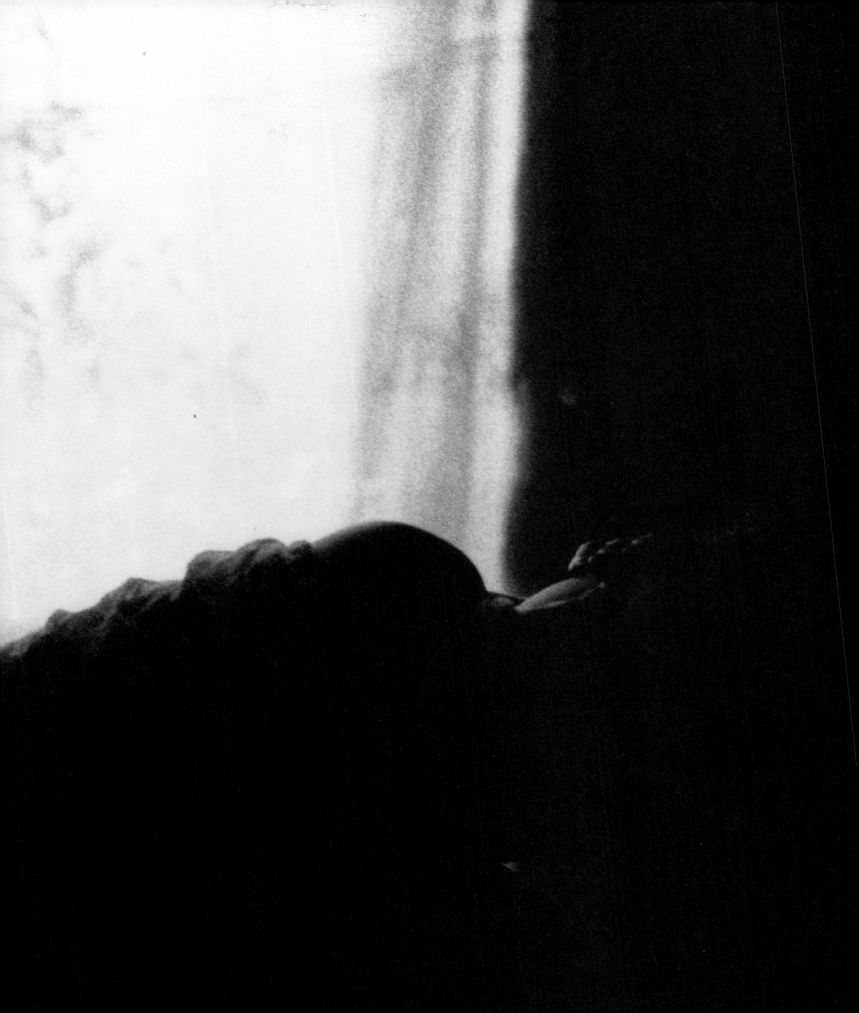

PROSTAMPA SUD GRAFICA EDITORIALE SRL